PAST & PRESENT

MONTICELLO

OPPOSITE: This c. 1910 photograph shows the Monticello Waterworks of that time. It was located on the east side of town. In the background the tower of the newly constructed First Presbyterian Church is visible. The church sat on the location now occupied by Drew County Farm Supply. (Courtesy Drew County Archives.)

PAST & PRESENT

MONTICELLO

Mark Spencer and Rebecca Spencer

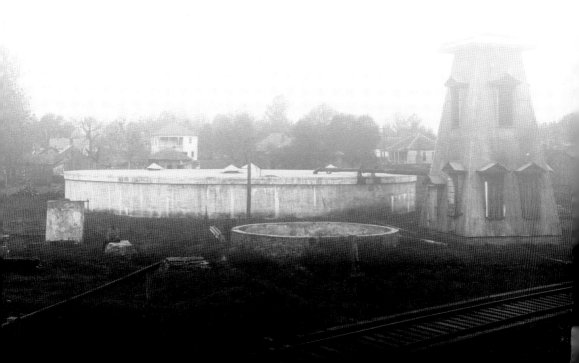

To everyone who has ever experienced Monticello, Arkansas, and made it what it has been, is, and will be

Copyright © 2023 by Mark Spencer and Rebecca Spencer
ISBN 978-1-4671-6017-9

Library of Congress Control Number: 2023933962

Published by Arcadia Publishing
Charleston, South Carolina

Printed in the United States of America

For all general information, please contact Arcadia Publishing:
Telephone 843-853-2070
Fax 843-853-0044
E-mail sales@arcadiapublishing.com
For customer service and orders:
Toll-Free 1-888-313-2665

Visit us on the Internet at www.arcadiapublishing.com

ON THE FRONT COVER: Built in 1906 as a testament to his success as an entrepreneur, Joe Lee Allen's home is an iconic representation of the city of Monticello. (Past, courtesy Mark and Rebecca Spencer; present, courtesy Rebecca Spencer.)

ON THE BACK COVER: Monticello got a new fire station in 1935. (Courtesy Drew County Archives.)

Contents

Acknowledgments vii
Introduction ix

1. Schools: Where Progress Begins, Where the Future Is Made 11

2. Commerce: An Entrepreneurial Spirit 27

3. Worship: Places to Enrich the Spirit 51

4. Community: A Desire to Serve 61

5 Homes: Reflections of Purpose and Personality 71

Acknowledgments

This book exists only because of the generous cooperation and assistance of the Drew County Historical Society, the Taylor Library at the University of Arkansas at Monticello (UAM), the Monticello Branch Library, fire chief Eric Chism, Mary Heady, Commercial Bank, Vicki Ross, Mike Pomeroy, Dr. Kate Stewart, Dr. Carole Martin, and Dr. Peggy Doss, chancellor of the University of Arkansas at Monticello.

The authors used a variety of sources in their search for historical photographs and information, including (but not exclusive to) articles from the *Advance Monticellonian*, yearbooks from Monticello High School, yearbooks from the University of Arkansas at Monticello, *The Encyclopedia of Arkansas,* interviews with long-time Monticellonians, *The Drew County Arkansas History of Medicine*, and the previous local history books *Images: A Pictorial History of Drew County* (1997), and Images of America: *Monticello* (2011).

A heavy debt is owed to the many local historians (past and present) who have, over the years, meticulously researched, organized, and analyzed records and then written eloquently of their conclusions and findings. Special recognition is due to Dr. Donald Holley, Dr. William F. Droessler, Sheilla Lampkin, Beth Thurman, Bettye Kellum, Claudia White, Kathy Davis, Annette Vincent, Shay Gillespie, Helen Guenter, Mary Tomlinson, and Connie Mullis.

The authors also wish to thank Amy Jarvis, their editor at Arcadia Publishing, for her patience, expertise, and guidance.

Introduction

The juxtaposition of the past with the present provides us with the compelling experience of seeing what remains unchanged over decades, what is no more, and what has been transfigured. A majestic Victorian mansion dominates its surroundings as it has for 117 years. A French castle out of a fairy tale has vanished. A vacant field with a cluster of stubby trees is now a vast shopping center.

It was another world 40, 60, 80, 100 years ago. Could any of us who were alive 40 years ago have imagined the world of 2023? What would be the reaction of a time traveler from, say, 1870? Surely, he would be shocked and in awe of automobiles and trucks, the smells of engine exhaust instead of the odors of horses and mules, the paved roads and concrete sidewalks, lights containing no fire, the strange and scandalous attire of both men and women, the odd speech patterns of these scantily clad people, and the omnipresent handheld magical little boxes emitting images and sounds.

Also strange to this time traveler would be the way people behave and think in 2023. How many truths of life from 1870 would he find displaced by odd, newly cherished beliefs? On the surface of the world, there would be little that was familiar to someone from the nineteenth century, little to take comfort in—until perhaps he visited businessmen in their shops hard at work, families in their homes at mealtime, parishioners in their churches worshipping, government officials in their offices solving problems and planning the future, teachers in their classrooms instilling knowledge with hope for a rising generation. Then the time traveler might find remnants of 1870 in certain timeless and universal truths.

Monticello has its roots in a village settled in 1836 known as Rough and Ready Hill, a chaotic community of personal feuds leading to brawls and killings. Established less than a mile from Rough and Ready as the seat of Drew County in 1849, Monticello derived its name from the desire of its founders to find civility, culture, and elegance—as reminiscent of the Virginia home of Thomas Jefferson.

Between 1870 and 1872, Monticello saw the construction of a new courthouse—the quintessential symbol of order and civilization—and for half a century, this French castle towered over the businesses and residences of the continuously growing and prospering town.

The desire for elegance was well-established with the building of the French castle courthouse, and Monticello saw many elegant churches and homes constructed during its gilded age of 1890 to 1920. Chicago-trained architect Sylvester Hotchkiss had made his way to the warmth of the South at the advice of his physician and designed many private homes, as well as churches and schools, some of which still stand today, including the mansion of Joe Lee Allen, whose rise from poverty as a farm boy reared by a widowed mother to become a leading entrepreneur and bank president epitomized the American dream—achieved through hard work, perseverance, and integrity in the context of the opportunities afforded by Monticello.

Dense timberlands, rich soil, railroads, cotton gins, an entrepreneurial spirit, and the recognition of the value of education made Monticello the premier community of southeast Arkansas.

At the center of its prosperous history have been its schools, in particular the Fourth District Agricultural School (SAS) created by an act of the state legislature in 1909. In the years to come, SAS evolved into Arkansas A&M College and, in 1971, the University of Arkansas at Monticello.

The authors made a deliberate effort to avoid the mere repetition of content found in the 2011 book Images of America: *Monticello* (also published by Arcadia Publishing). That book contains information and images pertaining to such interesting episodes in Monticello's history as the UAM Wondering Weevils football team of the late 1930s and early 1940s, as well as features of such prominent historical figures as Frank Horsfall, the first president of Arkansas A&M, and William Edgar Spencer, an attorney, judge, and legislator who wrote poetry under the pseudonym Henri Faust and won the 1929 Yale Younger Poets Award. The authors hope that the two books complement each other and that, together, they provide a rich history of Monticello.

Nonetheless, the authors acknowledge that no history is complete and that the inclusion of material is a matter of availability of information and space limitations. Of course, in all communities, folklore and fact blur together. Imagination, faulty memory, politics, prejudice, and pride keep history in flux.

This book focuses on locations that reflect the values, lifestyles, and opportunities of those who came before us and of those of us here now.

Although in recent decades commerce has largely shifted from the historic downtown "square" to Highway 425—the sites of Walmart, Walgreens, McDonald's, Dairy Queen, Wendy's, Ace Hardware, Sonic, Hampton Inn, and Holiday Inn Express—the historic district has been revitalized by the renovation of the Ridgeway Hotel, which was built in the early 1930s and played host to Big Bands like Count Basie and Glenn Miller; it is now residential housing for retirees. The square has also received facelifts to its fountain and sidewalks, and a strikingly beautiful mural now adorns the southwest corner of the square depicting the richness of the town's past and present.

The authors hope that this book will provide pleasure, knowledge, and pride. A history that juxtaposes the past and the present makes us all time travelers.

CHAPTER 1

SCHOOLS

Where Progress Begins, Where the Future Is Made

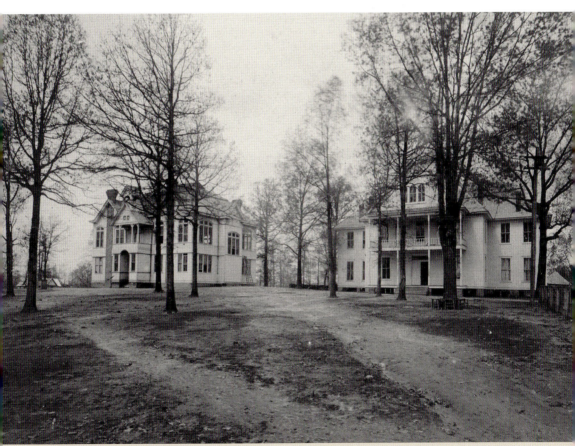

In 1890, John Hinemon founded Hinemon University School. The campus consisted of the academic building and the girls' dormitory. It was located on West College Avenue. The buildings burned down in 1915, and the campus subsequently became the site of the old Monticello High School. (Courtesy Drew County Archives.)

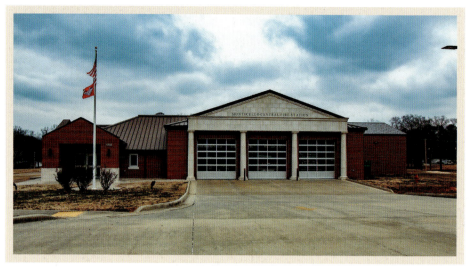

The first school on the site of Whaley Elementary was a white frame construction, in the loft of which Confederate States Army (CSA) colonel W.F.S. Slemmons allegedly hid to avoid capture by Union soldiers in 1864. Beginning in 1908, the red brick building pictured here served as Monticello Grammar School. The front entrance was for boys, and the back entrance was for girls. In 2019, the new fire station was constructed on the site. (Past, courtesy Drew County Archives; present, courtesy Rebecca Spencer.)

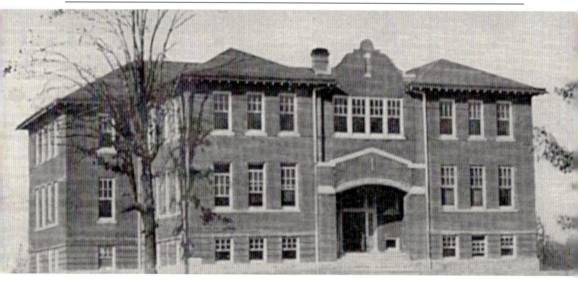

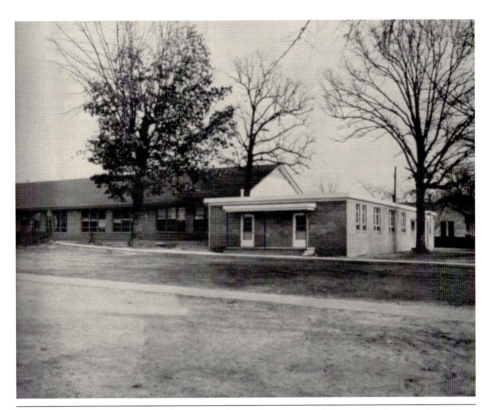

The historical photograph here of the Administration Building for the Monticello School District is from the 1955 *Hillbilly* yearbook. In 2022, the state of Arkansas honored the Monticello School District with a "Schools on the Move Toward Excellence" designation. The Schools on the Move campaign celebrates schools that show positive trends in student performance. (Past, courtesy Mark and Rebecca Spencer; present, courtesy Rebecca Spencer.)

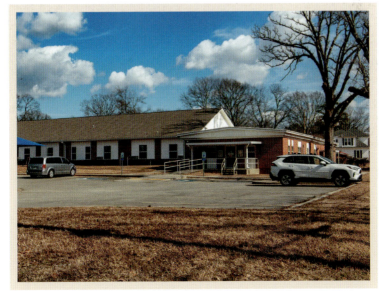

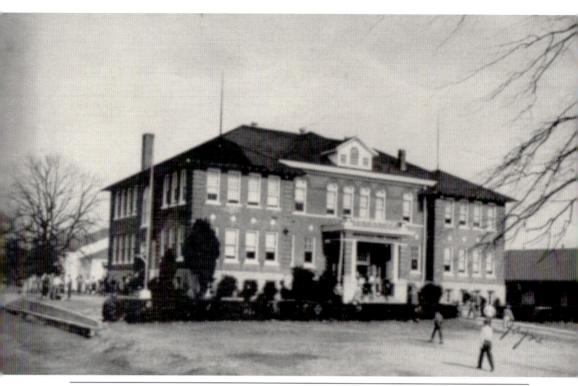

The old Monticello High School was built in 1915 at the corner of West College and North Hyatt on the site of Hinemon University, which was destroyed by fire that same year. The historical photograph here was taken for the 1955 *Hillbilly* yearbook, the editor of which was Zach McClendon, who is now a prominent local business. The high school was torn down in 1989. (Past, courtesy Mark and Rebecca Spencer; present, courtesy Rebecca Spencer.)

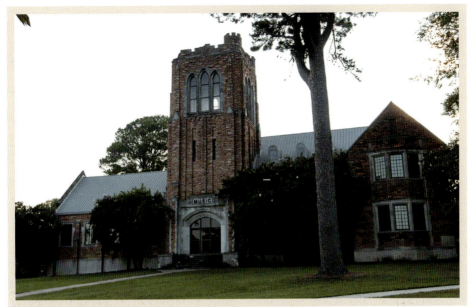

The Music Building on the UAM campus was constructed in 1934 as the Fine Arts Building, which provided classrooms, practice rooms, faculty offices, and the Harris Recital Hall, where both musical and theatrical performances were held. The building is still used for its original purposes. The 2022 photograph records the result of a recent event: the lightning strike that destroyed the left turret. The turret will be rebuilt. (Past, courtesy UAM Library; present, courtesy Rebecca Spencer.)

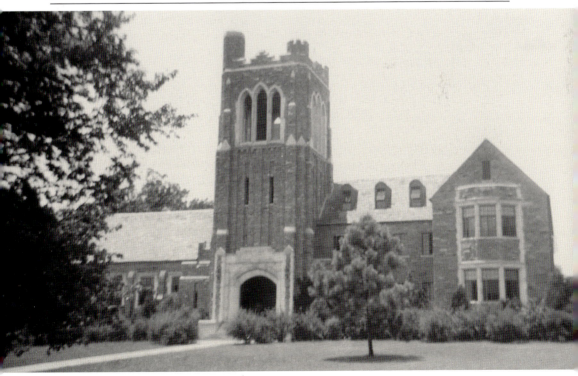

The Henry H. Chamberlin Forest Resource Complex on the UAM campus houses the College of Forestry, Agriculture and Natural Resources (CFANR), the only such college in Arkansas. In 1945, in recognition of the prominence of the forestry industry in southeast Arkansas, Arkansas A&M president Marvin Bankston hired the noted forester Henry Chamberlin to establish a forestry program. The Chamberlin Annex, seen in the 2022 photograph, was added in 2017. (Past, courtesy UAM Library; present, courtesy Rebecca Spencer.)

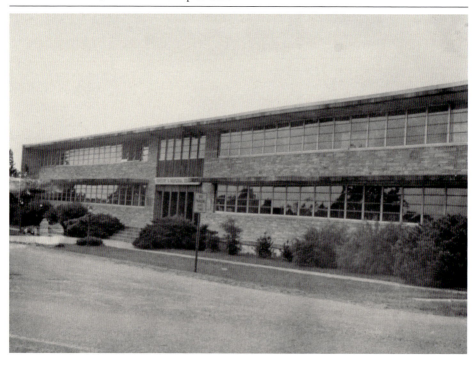

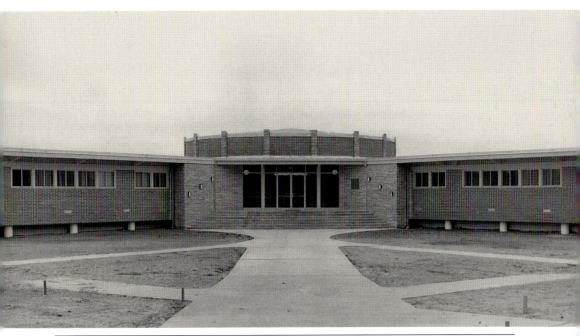

Constructed in the early 1960s, the Science Center Building on the UAM campus houses the School of Mathematical and Natural Sciences, which offers bachelor of science degrees in four major areas: biology, chemistry, mathematics, and natural sciences. The school's pre-professional programs in allied health, pre-dentistry, pre-medicine, pre-optometry, and pre-pharmacy are renowned across the state, largely because of the nearly 100 percent placement rates in professional schools. (Past, courtesy UAM Library; present, courtesy Rebecca Spencer.)

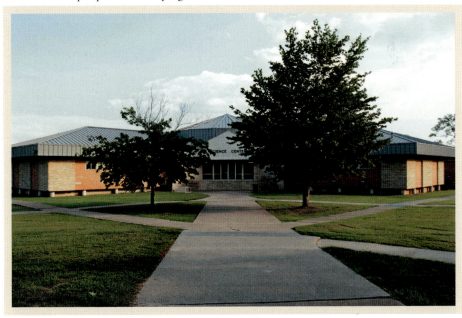

SCHOOLS

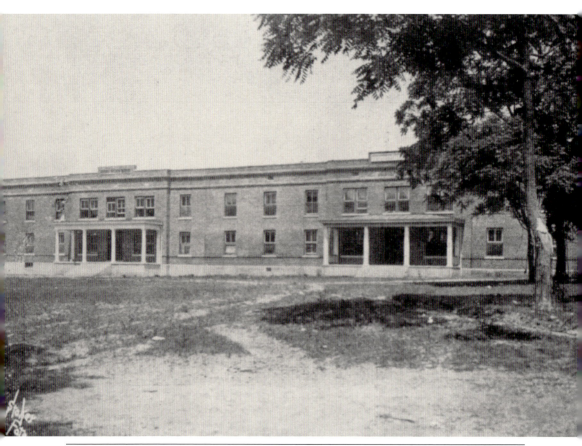

Now housing the offices and classrooms for the UAM School of Education, Willard Hall was constructed in 1912 as a dormitory for 120 co-eds. Publicity for the newly constructed dormitory proclaimed, "The rooms are large and well-ventilated; the halls are wide and light; conditions are perfectly sanitary. Steam heat and electric lights." (Past, courtesy Drew County Archives; present, courtesy Rebecca Spencer.)

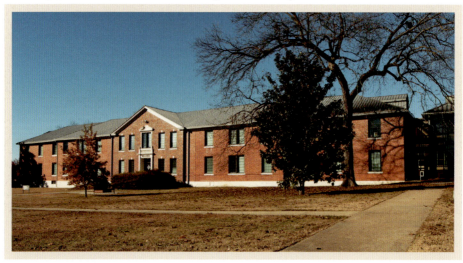

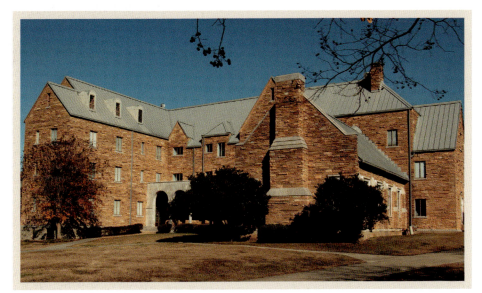

Built in the 1930s, UAM's Horsfall Hall is a women's dormitory. Frank Horsfall was named the first principal of the Fourth District Agricultural School in 1910 and subsequently the first president of the Fourth District Agricultural and Mechanical College. During the social and cultural turbulence of the Roaring Twenties, he banned dances and required male and female students to remain on opposite sides of an invisible line through campus. (Past, courtesy Drew County Archives; present, courtesy Rebecca Spencer.)

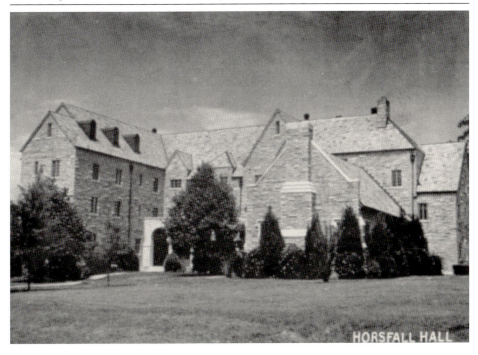

SCHOOLS

With the influx of World War II veterans taking the opportunity to attend college on the GI Bill, Arkansas A&M was faced with a housing shortage in the late 1940s, the solution to which was to place trailers next to Weevil Pond. Today, UAM's Administration Building housing academic affairs and the advancement offices sits next to the pond. (Past, courtesy UAM Library; present, courtesy Rebecca Spencer.)

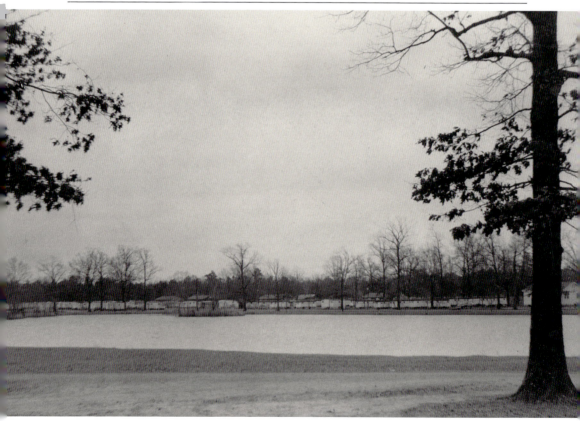

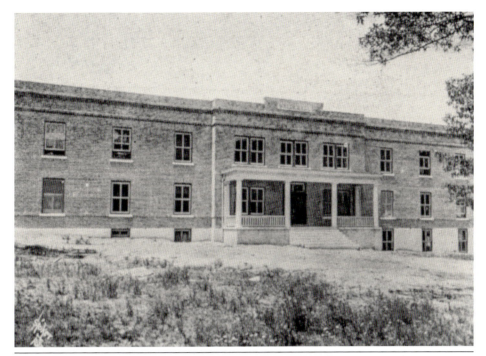

Built around 1913, Wells Hall (named for the prominent Wells family of Monticello) was the "boys" dormitory for the Fourth District Agricultural School. Having undergone many renovations on the interior and exterior over the years, including the elimination of a flat roof, Wells Hall now houses UAM's communication and debate programs. The latest renovations took place in 2007. (Past, courtesy UAM Library; present, courtesy Rebecca Spencer.)

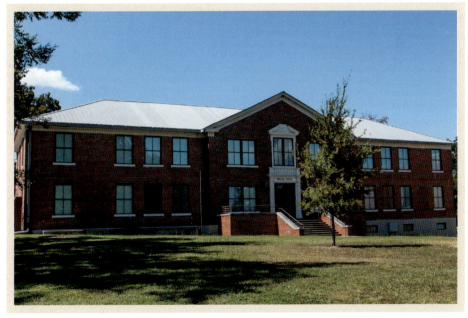

Schools

The historical image from the early 1950s shows what is now named the Babin Business Center after the former president of Arkansas A&M Dr. Claude Babin, under whose administration Arkansas A&M became the University of Arkansas at Monticello in 1971, a progressive period in Arkansas led by Gov. Winthrop Rockefeller. Rockefeller's election paved the way for another progressive governor, Bill Clinton. (Past, courtesy UAM Library; present, courtesy Rebecca Spencer.)

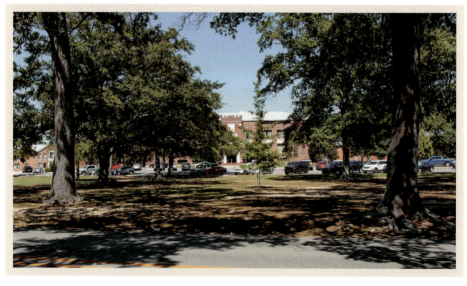

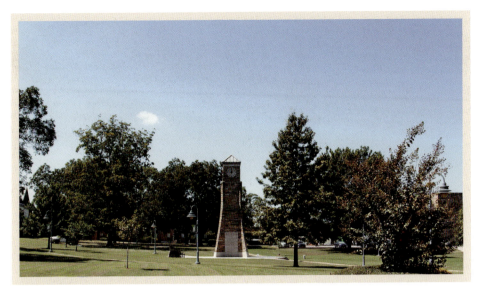

For decades, this giant foliate oak was a symbol of UAM. Pictured here in the early 1900s, the tree was over 300 years old and had a limb spread of 113 feet. It was cut down in 1983 after university officials determined that the tree was diseased and had become a safety hazard. Its place at the heart of campus is now occupied by a clock tower commemorating UAM's centennial. (Past, courtesy UAM Library; present, courtesy Rebecca Spencer.)

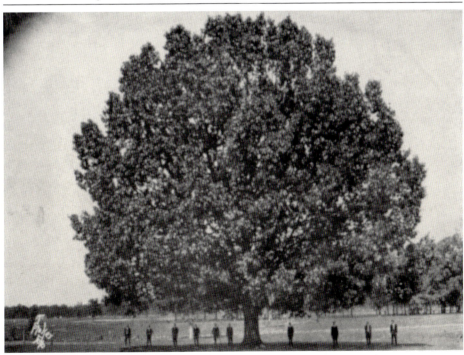

SCHOOLS

Memorial Classroom Building (MCB) on UAM's campus was constructed in 1939 and originally served as the Science Building. It was renamed after World War II to honor the sacrifices of America's veterans. With many Art Deco flourishes preserved inside and out, MCB now houses the School of Social and Behavioral Sciences (including the social work program) and the School of Arts and Humanities. (Past, courtesy UAM Library; present, courtesy Rebecca Spencer.)

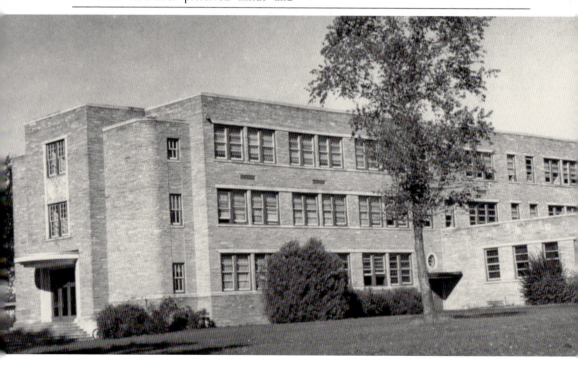

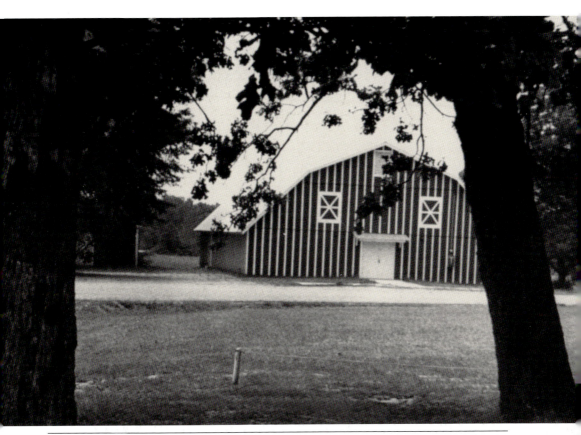

The Red Barn on the campus of UAM has served a range of purposes over the years. For example, at one time, it was used as a band hall. At another, it housed the School of Education while Willard Hall was being remodeled. In recent years it has provided space for student government business. (Past, courtesy UAM Library; present, courtesy Rebecca Spencer.)

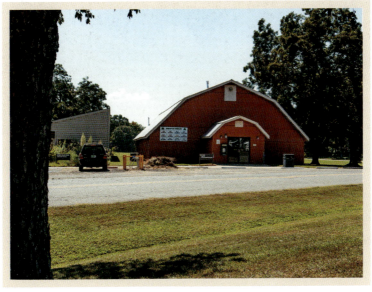

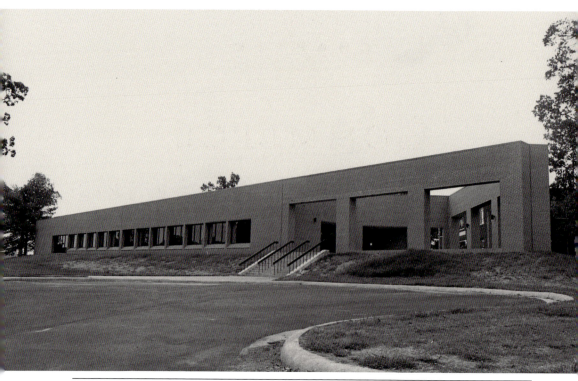

Stretched along the west side of Weevil Pond, UAM's Administration Building was constructed in the mid-1970s and houses the offices for academic affairs, alumni relations, and advancement. The Administration Building was used to house the offices of the chancellor. The current UAM Chancellor, Dr. Peggy Doss, has her offices on the second floor of the recently constructed Student Success Center. (Past, courtesy UAM Library; present, courtesy Rebecca Spencer.)

CHAPTER 2

COMMERCE
An Entrepreneurial Spirit

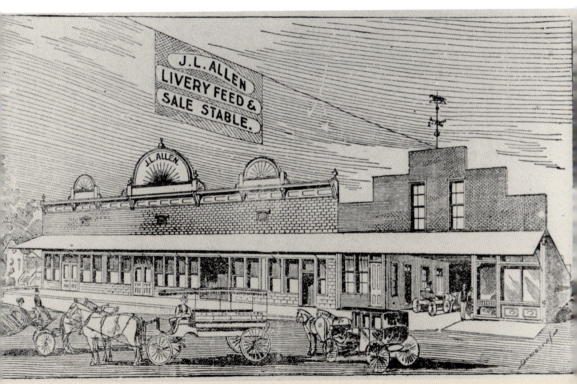

The J.L. Allen Livery Feed & Sale Stable was a prosperous business on East Gaines Street from the 1890s until the death of Joe Lee Allen in 1917. Allen's newspaper advertisements declared, "I have the swellest buggies, run-a-bouts and surries ever seen in this town." (Courtesy UAM Library.)

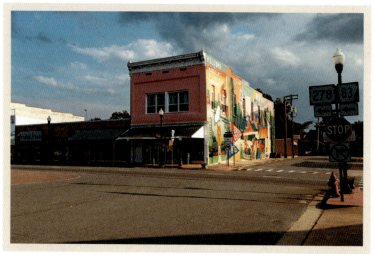

This building at the southwest corner of the town square has existed in a variety of incarnations over the past century. Now as motorists and pedestrians approach the square from Highway 425, they are welcomed by a mural covering the entirety of the building's west side. Created by Erin Ashcraft, who was born and raised in Monticello, the mural vividly depicts images that evoke the history and culture of the community. (Past, courtesy UAM Library; present, courtesy Rebecca Spencer.)

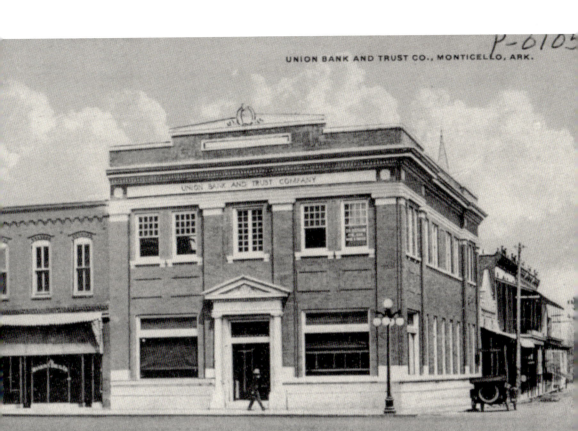

The Union Bank and Trust Company was formed in September 1915 with the merger of Monticello's two oldest banks, Citizens Bank and Monticello Bank. The historical image shows the building the bank occupied around 1920 at 102 West McCloy on the north side of the square. Today's modern building is at the same location. (Past, courtesy Drew County Archives; present, courtesy Rebecca Spencer.)

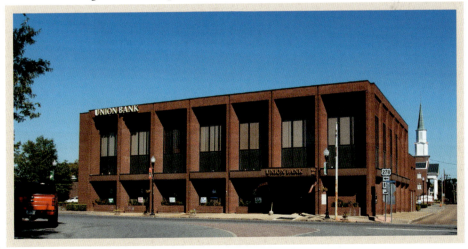

Commerce

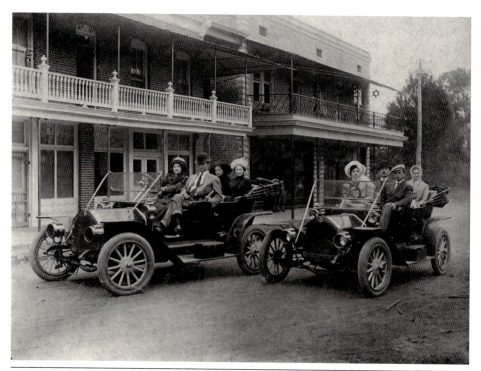

The corner building in this 1910 photograph is the Star Hotel. The location is now clearly the back of Union Bank. In the backseat of the car on the right are Dr. and Mrs. Frederick Lindsey Duckworth. Dr. Duckworth was the college physician for Arkansas A&M College and had a private practice in Monticello. He was killed by lightning in 1935 at the age of 53. (Past, courtesy Drew County Archives; present, courtesy Rebecca Spencer.)

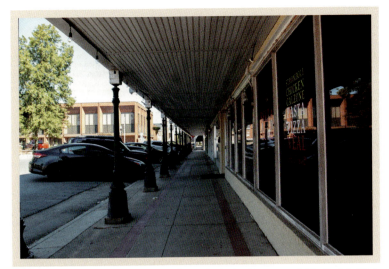

After a significant spring hail storm in the mid-1950s, business owners and employees sweep hail stones on the east side of the square. Pictured here in front of The Model, a women's clothing store, are Mike Cavaness, D.A. Anderson, and Ola Smith. Union Bank is prominent in the background. (Past, courtesy Drew County Archives; present, courtesy Rebecca Spencer.)

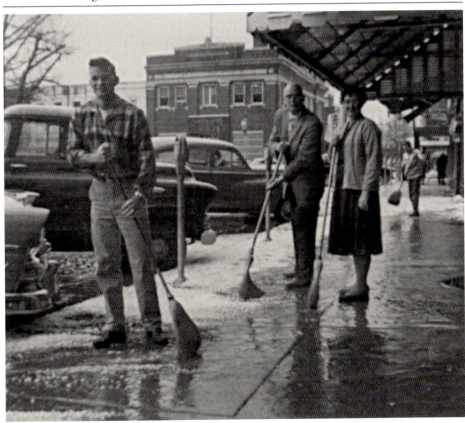

Commerce

Dramatic changes are evident in these images of the south side of the square, where the block is now occupied, in part, by Options 1 Donation Center and Options 2 Thrift Store. Commercial Bank is also a prominent presence today. In the 1940s, Corner Drugs and Monticello Drugs were busy pharmacies with lunch and soda counters. There was also a "recreation parlor." (Past, courtesy Drew County Archives; present, courtesy Rebecca Spencer.)

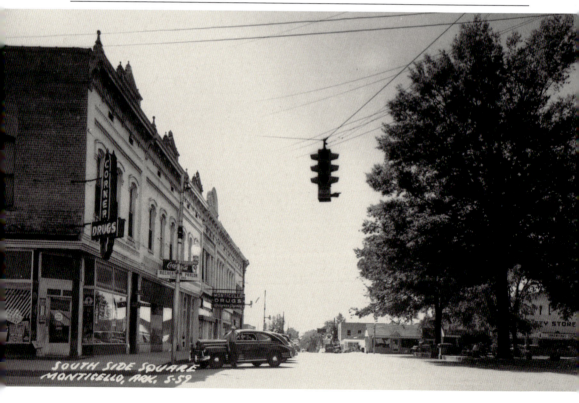

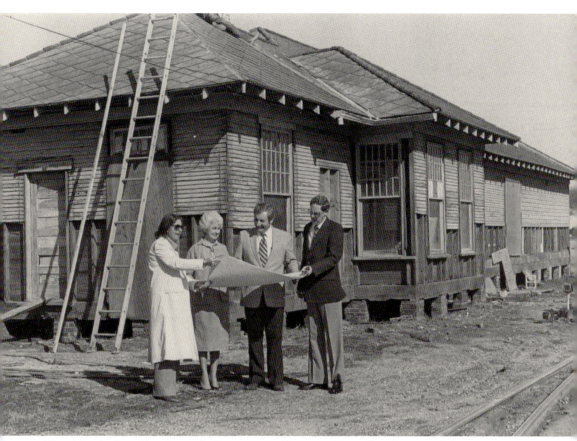

The Monticello Chamber of Commerce building east of the square was originally a railroad depot serving the Ashley, Drew & Northern (AD&N) Railway, which operated 40.7 miles of track between Monticello and Crossett. The railroad operated from 1912 until 1996, its origin lying with the Crossett Railway, a 10-mile stretch of track built in 1905. (Past, courtesy Drew County Archives; present, courtesy Rebecca Spencer.)

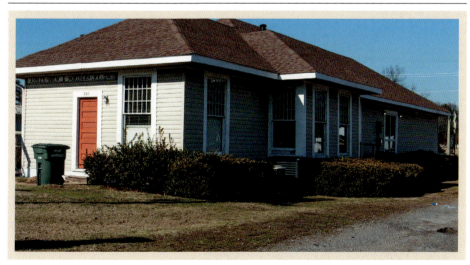

Commerce

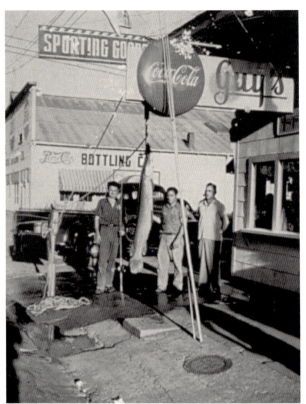

Guy's Sporting Goods stood on East Gaines Street. In the historical photograph here, taken in the summer of 1953, Clarence Boone, Louis "Doc" O'Neill, and Guy Echols are showing off an eight-foot, 227-pound gar caught on the Saline River. The Pepsi-Cola bottling plant in the background was torn down in February 2023. (Past, courtesy Mark and Rebecca Spencer; present, courtesy Rebecca Spencer.)

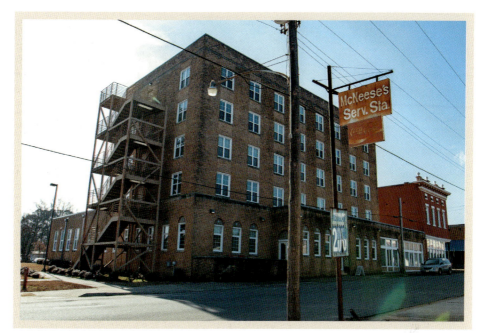

Located near the train depot, the Ridgeway Hotel began accommodating travelers in the early 1930s. In its efforts to compete successfully with the well-established Allen Hotel across the street, the Ridgeway hosted famous swing bands, like those of Count Basie and Glenn Miller. In the past decade, it has been renovated to provide residential housing for retirees. (Past, courtesy Drew County Archives; present, courtesy Rebecca Spencer.)

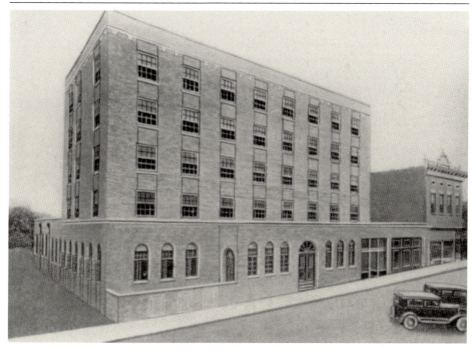

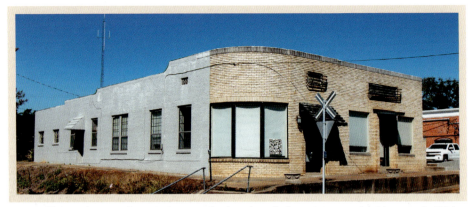

Pictured here is the Dr. Johnny P. Price medical clinic. Dr. Price (1907–1988) graduated from the University of Arkansas Medical School and was engaged in general practice and surgery in Monticello from 1934 until his death and was a co-owner of Monticello Hospital. He shared this 1930s-era building with Walter Carter Insurance. The building was recently occupied by Hope Place, a pregnancy care center, but is currently vacant. (Past, courtesy Drew County Archives; present, courtesy Rebecca Spencer.)

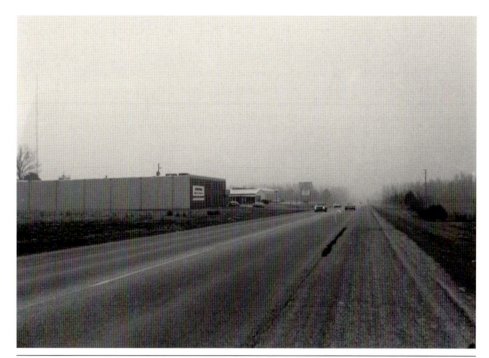

In the early 1970s, Highway 425 was two lanes skirting the western edge of Monticello and was just starting to see some business development. Today, commerce has largely shifted from the town square to this area with North Park Plaza's many restaurants and retail stores, the multiplex movie theater, and of course, there is Walmart. (Past, courtesy UAM Library; present, courtesy Rebecca Spencer.)

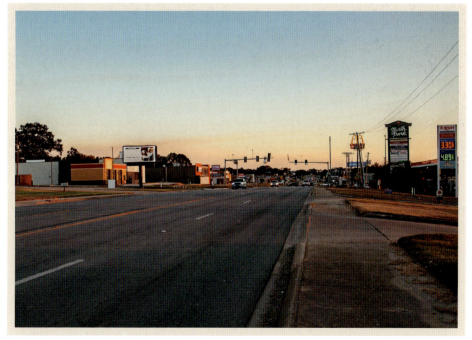

COMMERCE 37

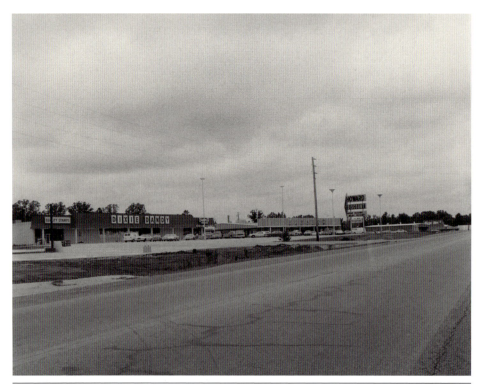

The historical image of Highway 425 is from around 1980. Older residents will remember Howard Discount and the Dixie Dandy supermarket, as well as the Quality Stamps store, where trading stamps could be exchanged for a wide variety of merchandise. Today, the Sherwin-Williams paint store and Auto Zone are long-established and successful businesses representing the transition from local to national chain stores. (Past, courtesy UAM Library; present, courtesy Rebecca Spencer.)

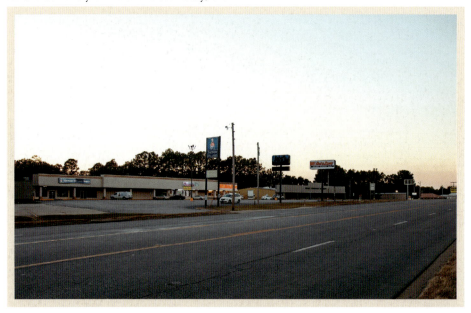

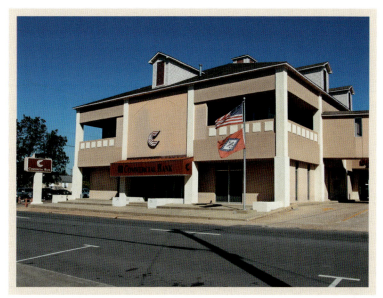

Commercial Bank was established on January 1, 1913, as Commercial Loan & Trust Company. On January 1, 1965, the name was changed to Commercial Bank & Trust Company. Its first president was the local entrepreneur Joe Lee Allen, who invested heavily in Monticello and the surrounding area. He was, for instance, the chief investor in the new community of LaDelle in 1912. Ladelle is named after Allen's daughter. (Past, courtesy Commercial Bank; present, courtesy Rebecca Spencer.)

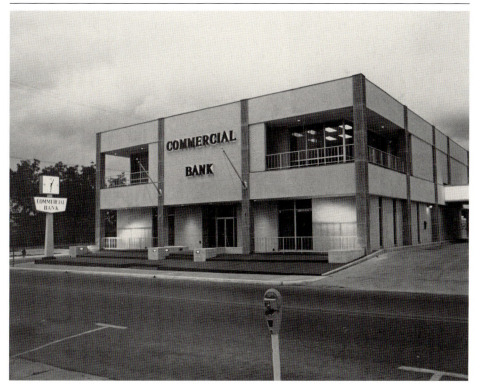

Commerce

The original Drew Theatre opened on August 9, 1938, at 300 West Gaines Street. Its seating capacity was reported as 900 in the newspaper the *Daily Film*. The project cost $50,000. The architect was H. Ray Burks. The building burned in July 1953. Another Drew Theatre is located off the square at 100 South Chester Street with 714 seats but has been vacant for many years. (Past, courtesy Drew County Archives; present, courtesy Rebecca Spencer.)

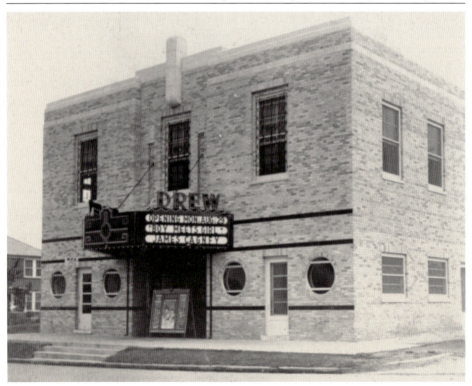

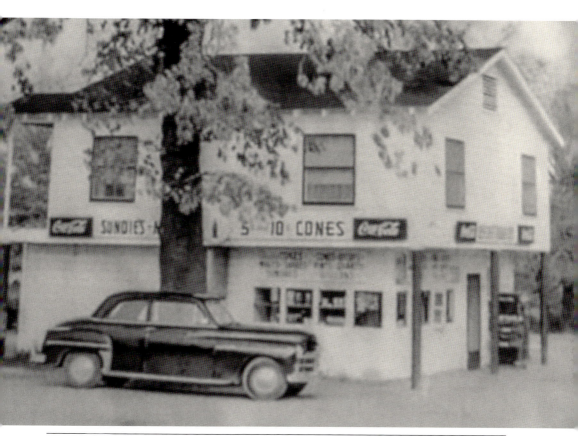

Bee Dee's operated from about 1950 until the 1970s at the corner of West Gaines and North Hyatt. Many older Monticellonians have fond memories of the restaurant. It had both an outside pick-up window and a small indoor dining area. It served diner fare such as made-to-order hamburgers, "Curly Q" fries, pork sandwiches, sodas, and chocolate-dipped ice-cream cones. Bee Dee's was especially popular with Arkansas A&M students. (Past, courtesy Drew County Archives; present, courtesy Rebecca Spencer.)

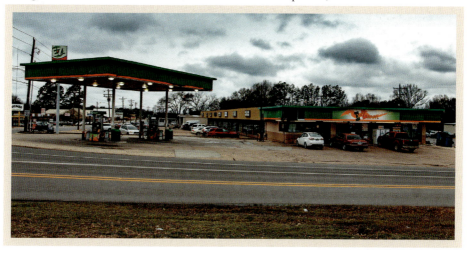

COMMERCE 41

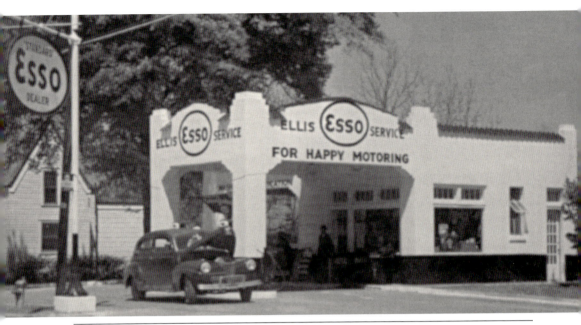

Some residents of Monticello will remember when all gas stations provided "full" service and drivers stayed in their cars while an attendant pumped the gas, cleaned the windshield, and often checked the tires and oil, as was the case in the 1940s at the Ellis Esso Service Station at the corner of South Main Street and West College Avenue. (Past, courtesy Drew County Archives; present, courtesy Rebecca Spencer.)

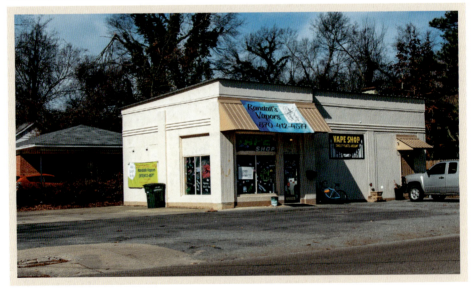

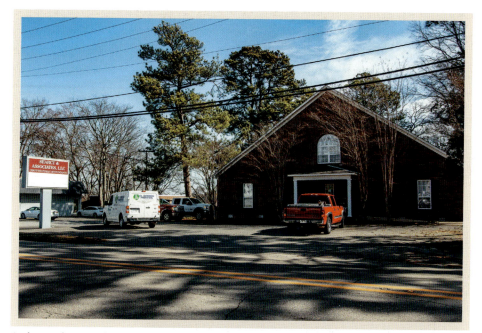

A place to buy snacks, tires, batteries, and ethyl gasoline, Owen station was a beacon in the night with its lit gas pumps at South Main Street and East Shelton Avenue. In the 1920s, ethyl gasoline was heavily promoted as safe. A common belief was that ethyl alcohol would be the fuel of the future when oil ran out. On the site now is Searcy and Associates, LLC, certified public accounts. (Past, courtesy Drew County Archives; present, courtesy Rebecca Spencer.)

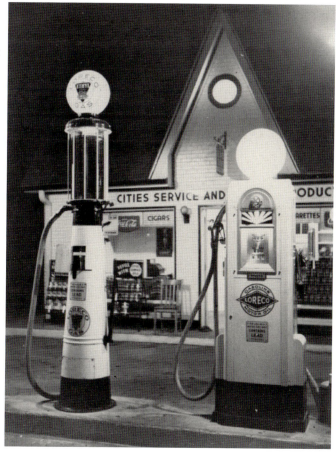

Commerce

In its new building constructed by Earl Baxter in 1952, the Carter Insurance Agency was located on Church Street across from the old fire station. In the historical photograph, the owner, Walter "Deacon" Carter, is standing in the back. The women in the picture are, from left to right, Stella Judkins, Ollie Carter, and Irma Haney. In 2023, the building is vacant. (Past, courtesy Drew County Archives; present, courtesy Rebecca Spencer.)

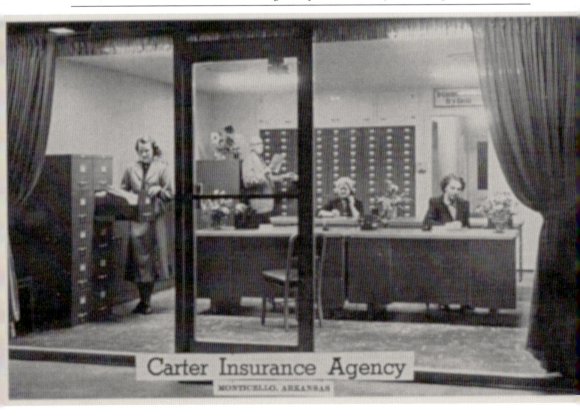

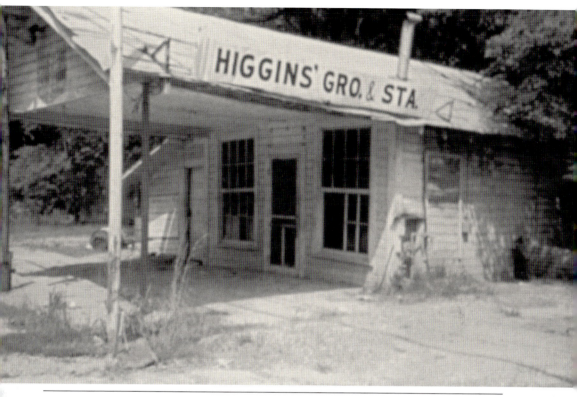

Higgins' Grocery, a true mom-and-pop operation, stood at the intersection of South Main and Midway Route. Owned by Marion Higgins, it was one of the last stores providing coal oil (kerosene). In 1989, Higgins was honored by the chamber of commerce for having the oldest private business in Monticello. It has been written that the store was dimly lit and that Higgins was a colorful character. (Past, courtesy Drew County Archives; present, courtesy Rebecca Spencer.)

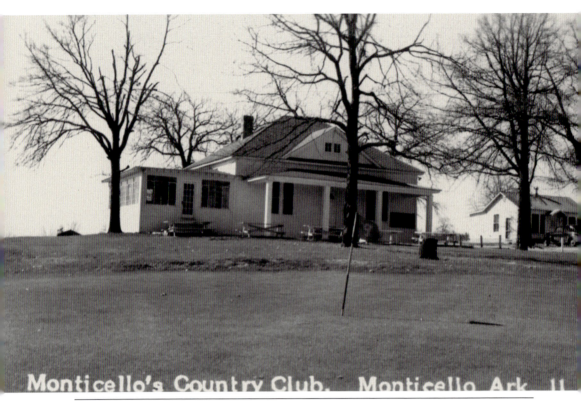

Founded in 1944 and first expanded in 1948 and greatly expanded over the years, the Monticello Country Club (MCC) has a nine-hole golf course, driving range, tennis courts, pickle ball, a swimming pool, and dining facilities. The clubhouse is available for special events, meetings, banquets, and weddings. MCC is a family-oriented private club. (Past, courtesy Drew County Archives; present, courtesy Rebecca Spencer.)

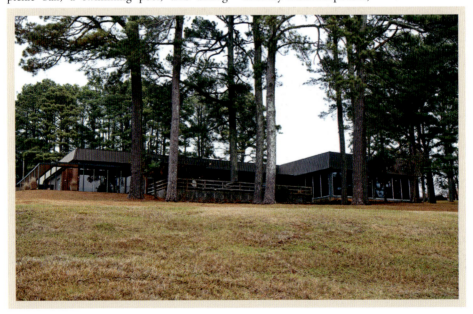

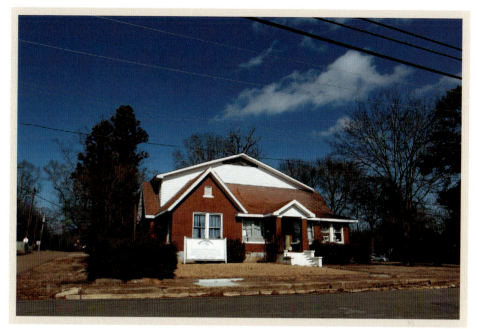

The Terra Cotter Hotel was located on the north side of East Trotter Street between the AD&N Railway depot about 200 feet west of the tracks, according to the Drew County Archives. It was owned and operated by Zeph Wood and his wife. After the Allen Hotel was built in 1912, the Terra Cotter saw its business significantly diminished, and the hotel was torn down in 1914. (Past, courtesy Drew County Archives; present, courtesy Rebecca Spencer.)

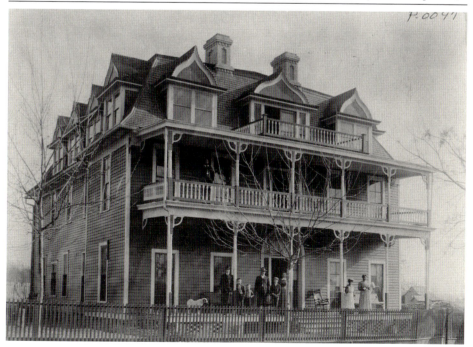

Commerce

47

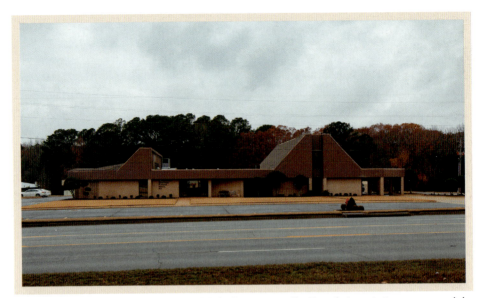

The Stephenson Funeral Home was established in 1928 out of a furniture store on the square by Edward Lee Stephenson. It then was moved to the house pictured here in the 1930s. During that decade, residents could join the Monticello Burial Association, sponsored by Stephenson Funeral Home. For annual dues, members were assured basic funeral services. (Past, courtesy UAM Library; present, courtesy Rebecca Spencer.)

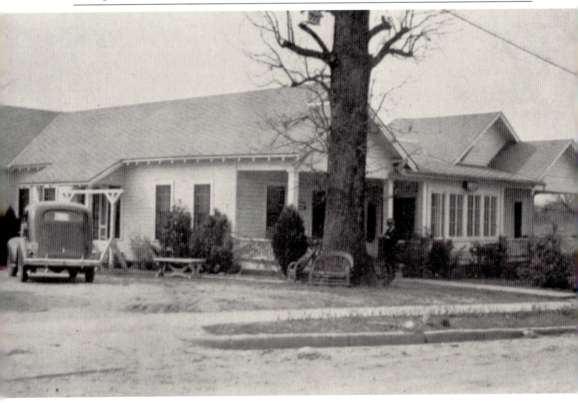

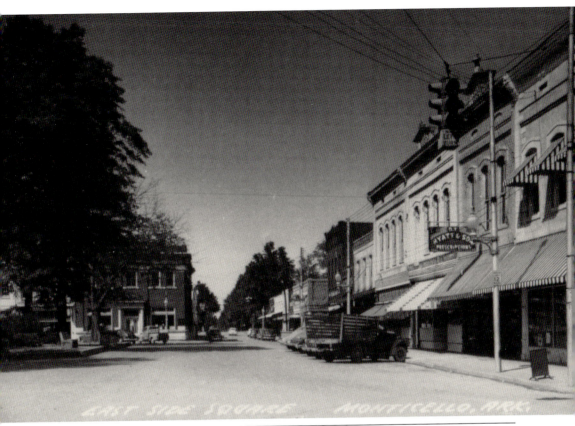

Today, the businesses on the east side of the square include Discount Merchandise, a popular furniture store. In the historical image, Hyatt Pharmacy played a significant role in the story of Ladell Allen's exchange of love letters with Prentiss Savage in 1948. Ladell would walk to the post office on the square, then go to Hyatt's to drink coffee, read her mail, and write replies. (Past, courtesy Mark and Rebecca Spencer; present, courtesy Rebecca Spencer.)

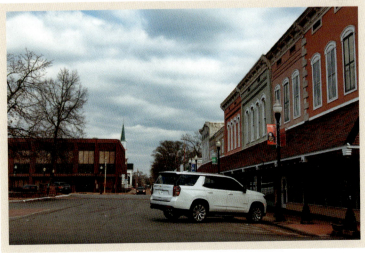

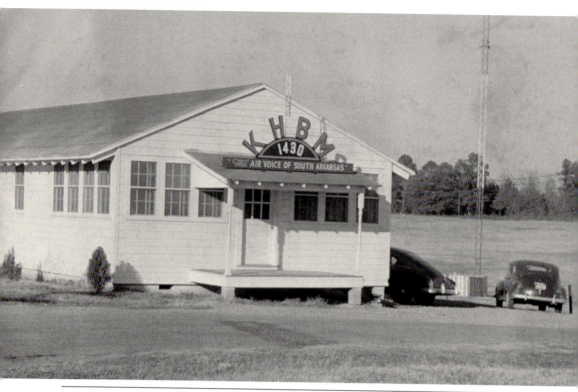

KHBM-AM, licensed in 1955, advertised itself as "the air voice of south Arkansas" and was originally located on the Arkansas A&M campus. The station was housed in a former World War II Italian prisoner-of-war camp building. Many such buildings were moved to the college following World War II and served various purposes. In 1979, a new station was built for KHBM at 279 Midway Route. (Past, courtesy UAM Library; present, courtesy Rebecca Spencer.)

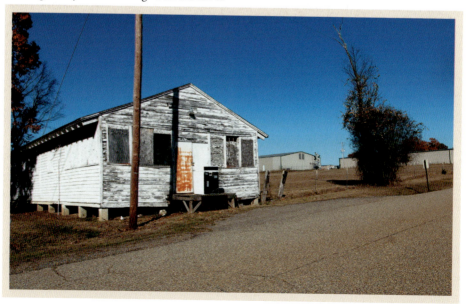

CHAPTER 3

WORSHIP
Places to Enrich the Spirit

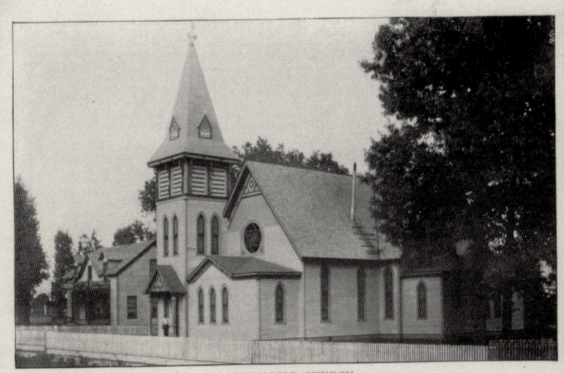

Not long after the migration of Drew County's center from Rough and Ready Hill to the more civilized environment of Monticello, a group of citizens organized The First Methodist Church in 1852. Its first building was erected in 1853. Pictured here is the 1890 building. (Courtesy Drew County Archives.)

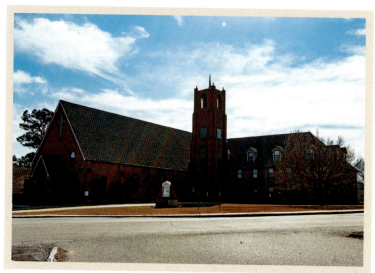

On July 15, 1911, a building committee was formed to plan the construction of a new (the third) Methodist Church building. Prominent businessman V.J. Trotter was chair of the committee with the minister H.M. Hankins as secretary. The building stood until 1950. The current building includes an education wing, constructed in 1950, and the sanctuary, constructed in 1954. (Past, courtesy Drew County Archives; present, courtesy Rebecca Spencer.)

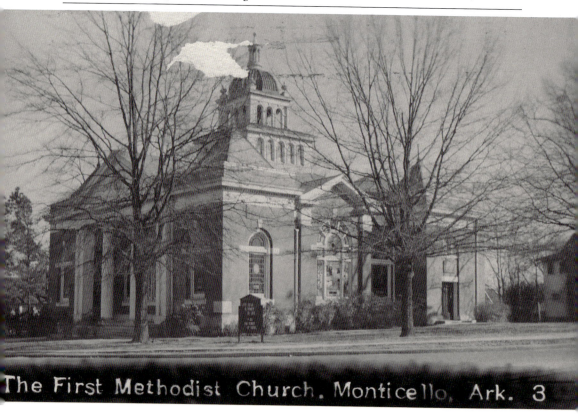

Worship

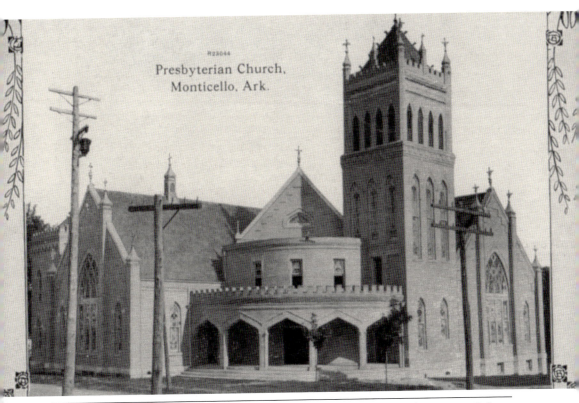

Despite the Victorian-style attractiveness of the ornate 1910 building, parishioners of the Presbyterian Church in the 1950s desired a more comfortable construction as their place of worship. The roof leaked, and there was no air conditioning. In 1955, the church property and lot were sold for $25,000 to Safeway Stores, Inc. Near the square, the site is now occupied by the Drew County Farm Supply. (Past, courtesy Mark and Rebecca Spencer; present, courtesy Rebecca Spencer.)

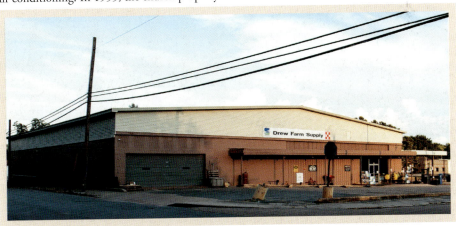

Worship

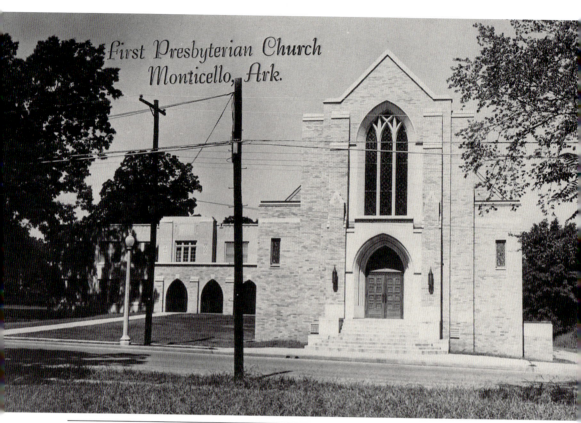

In 1956, First Presbyterian Church was built on the site of the Mack Wilson Hospital on North Main Street. The hospital was remodeled and used as part of the church for many years. The portion of the church seen on the left is largely the former front of the hospital with some added facade. A rear wing was also preserved and is still present today. (Past, courtesy Mark and Rebecca Spencer; present, courtesy Rebecca Spencer.)

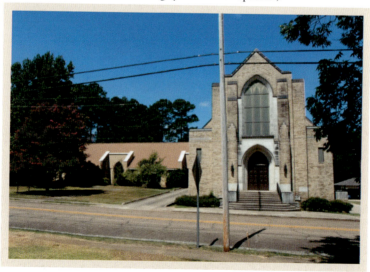

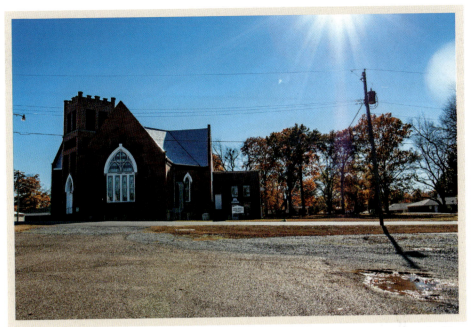

Standing at the corner of Wood Avenue and Church Street, Wood Avenue Associate Reformed Presbyterian Church was organized in 1855 under the leadership of the Rev. John Wilson, the grandfather of well-known Monticello residents Walter Wells, Minnie Wells, and Pattie Moffatt. The building pictured here is the congregation's third house of worship. Its construction and furnishings cost $8,800 in 1907. (Past, courtesy Drew County Archives; present, courtesy Rebecca Spencer.)

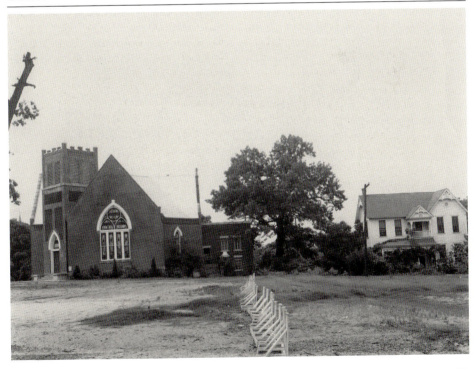

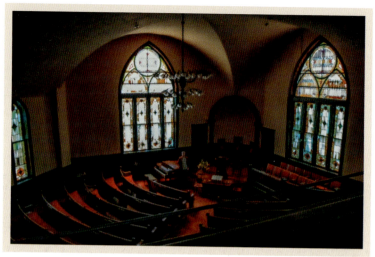

The interior of Wood Avenue Presbyterian Church is stunning in its beauty with its curved pews, rich wooden paneling, and stained-glass portraits. Its interior design is called the "Akron Plan," the name deriving from the design of a Methodist Episcopal Church in Akron, Ohio, built shortly after the Civil War. Moveable partitions can be opened or closed to create separate Sunday school classrooms or one large open space. (Past, courtesy Drew County Archives; present, courtesy Rebecca Spencer.)

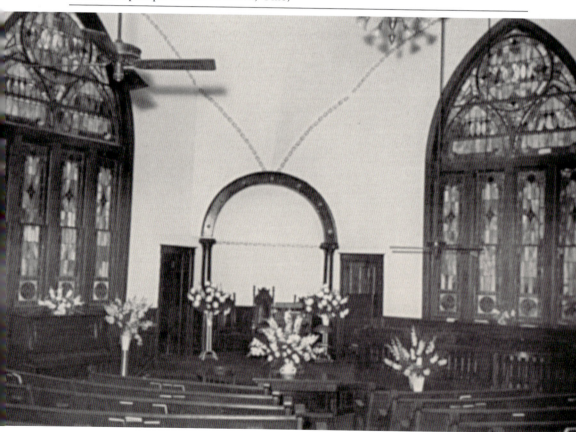

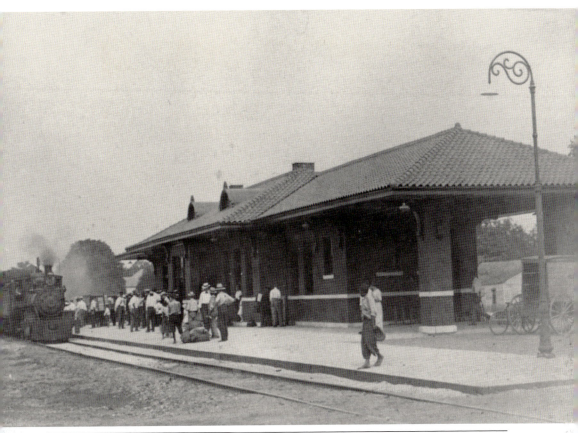

The Church of Christ stands on the site of the Missouri Pacific passenger depot, which served the Monticello community from 1912 to 1935 during an era when train travel was far safer and speedier than travel by any other means. The Church of Christ was one of three branches of the Restoration Movement, the others being the Christian Churches and the Disciples of Christ. (Past, courtesy Drew County Archives; present, courtesy Rebecca Spencer.)

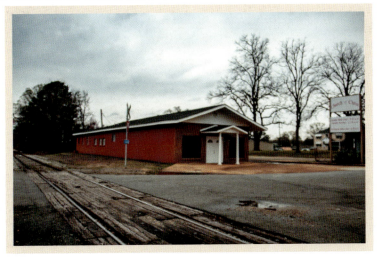

Worship

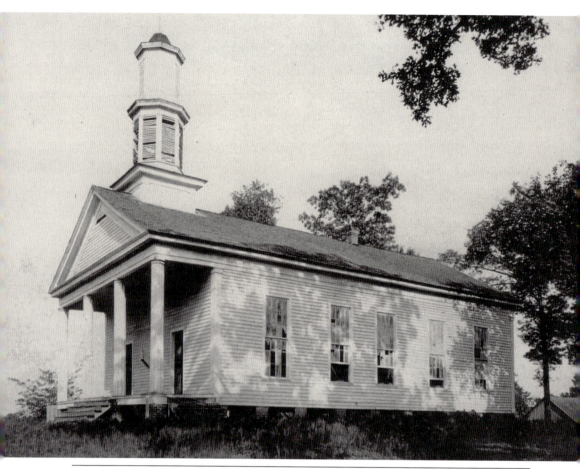

The original First Baptist Church, a white clapboard construction, was erected in 1860 near the town's center. It was razed in 1902. The church replacing it was made of bricks and featured soaring spires. It was on the same site as the original church. The current church is at the same location on North Main Street as the building it replaced but faces east rather than south. (Past, courtesy Drew County Archives; present, courtesy Rebecca Spencer.)

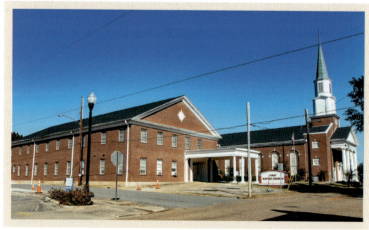

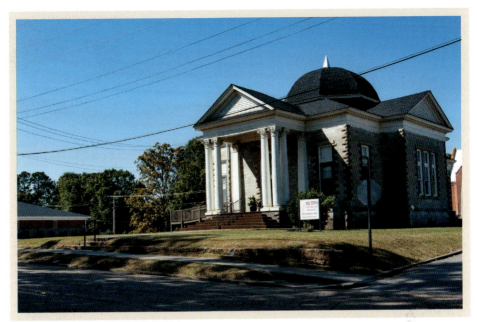

Built as a Christian Science Church in 1909, it was one of the last buildings designed by Monticello's most famous architect, Sylvester Hotchkiss. It still stands on North Main Street and serves as the place of worship for the congregation of The Holy Temple Church of God in Christ. (Past, courtesy Drew County Archives; present, courtesy Rebecca Spencer.)

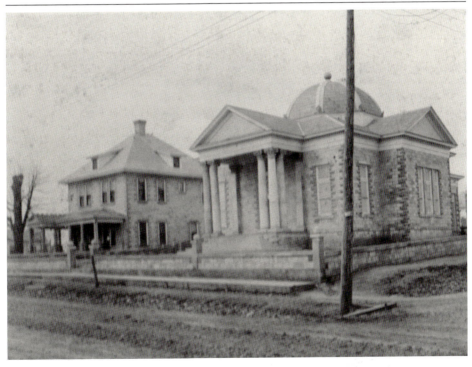

Worship

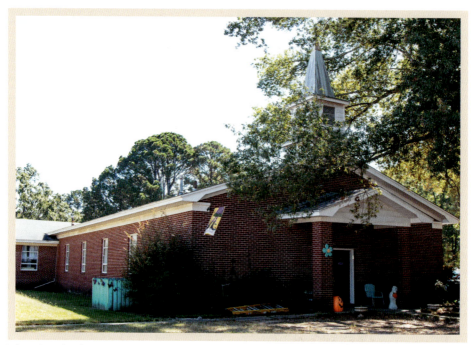

The Church of Christ at 631 South Gabbert Street is one of three in Monticello and one of many churches of Christ in southeastern Arkansas. The second-largest religious fellowship in the state after the Southern Baptists and just ahead of the United Methodists, the churches of Christ have congregations in all of the state's 75 counties. (Past, courtesy Drew County Archives; present, courtesy Rebecca Spencer.)

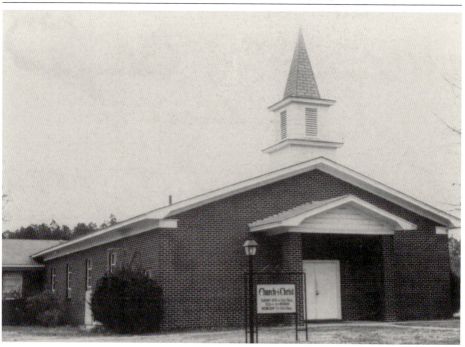

CHAPTER 4

COMMUNITY
A DESIRE TO SERVE

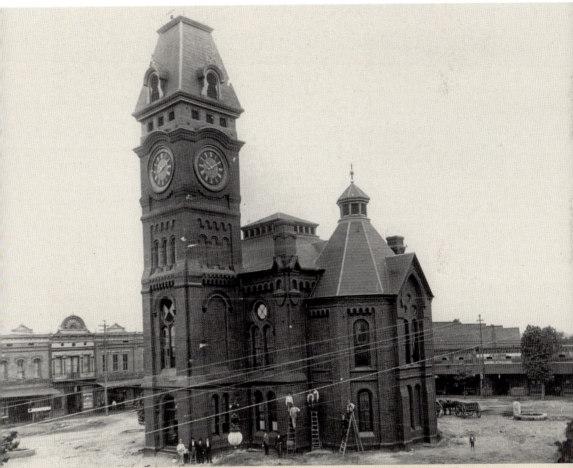

The cornerstone of the "French Castle" was laid in October 1870. The *Monticellonian* predicted that the construction of the new courthouse would raise property values by as much as 50 percent. Wanting to ensure that this symbol of a new era kept its elegant appearance, the county court threatened fines for spitting or writing on the courthouse. (Courtesy Drew County Archives.)

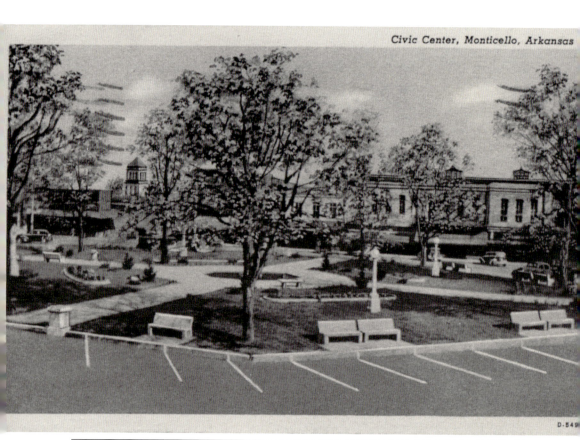

Civic Center, Monticello, Arkansas

In 1941, the Civic Center (or square) was the heart of downtown and surrounded by banks, clothing stores, and pharmacies. From 1872 until 1932, this was the site of Monticello's French Castle courthouse. Today, the Civic Center continues to be the heart of downtown and is surrounded by restaurants such as Bella Luna, banks such as Commercial Bank, city buildings, and retailers such as Discount Merchandise. (Past, courtesy Mark and Rebecca Spencer; present, courtesy Rebecca Spencer.)

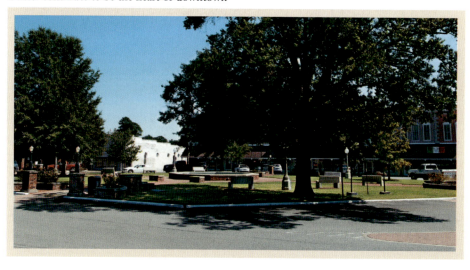

COMMUNITY

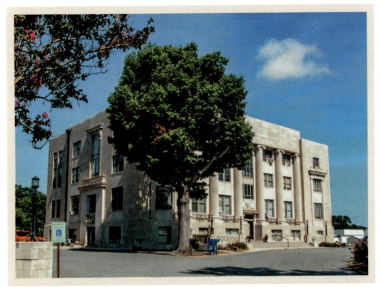

The French Castle courthouse built in the early 1870s provided inadequate space for the growing community by 1930. Drew County at that time was reaching its peak in population (the population today is approximately 20 percent less than in the 1920s). Structural issues also existed with the courthouse: primarily crumbling bricks fired locally. In this historical image, the Art Deco courthouse to be completed in 1932 is under construction. (Past, courtesy Drew County Archives; present, courtesy Rebecca Spencer.)

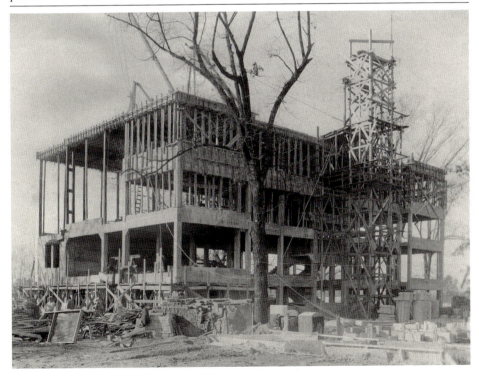

COMMUNITY

63

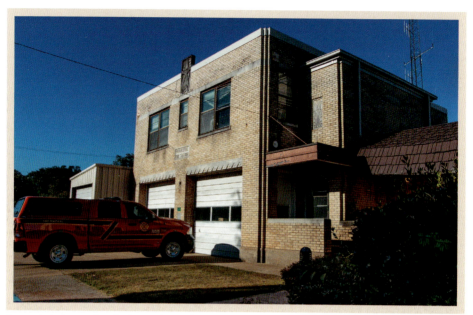

Located just south of the square, this fire station was one of a cluster of civic buildings including the city offices and the post office constructed as public works projects during the Great Depression. On the right side of the historical photograph, the old train station is in the background. This fire station was retired in 2015 after the construction of the new station on North Main Street. (Past, courtesy Drew County Archives; present, courtesy Rebecca Spencer.)

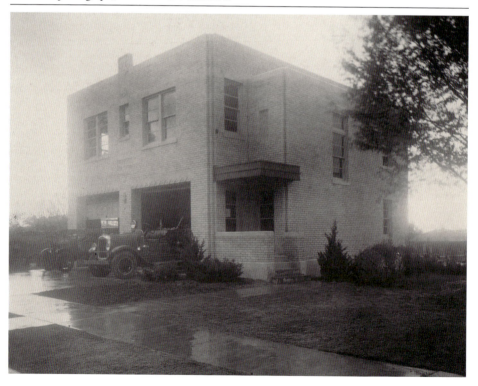

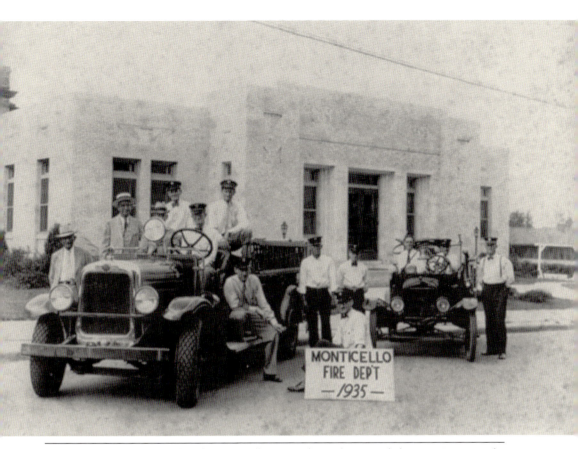

As Monticello has grown, so has the Monticello Fire Department, as seen in these images from 1935 and 2022. In 1930, the population of Monticello was 3,076—a jump of 29.4 percent from 1920. In the past 20 years, the population has exceeded 9,000. In 2022, the fire chief is Eric Chisom. The assistant chief is Joey Norton. (Past, courtesy Drew County Archives; present, courtesy Rebecca Spencer.)

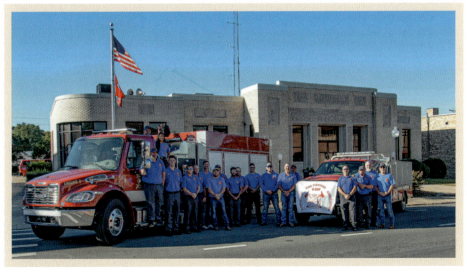

COMMUNITY 65

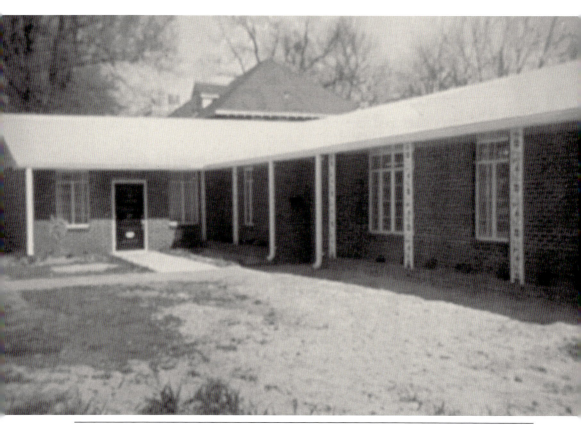

The historical photograph here shows the incarnation of the Monticello Branch Library built in the 1960s. Prior to the construction of this building, the library was housed in the Drew County Courthouse and was known as the Drew County Library. The name change resulted from the local public library becoming part of the Southeast Arkansas Regional Library and receiving state funding. The building now houses county offices and courtrooms. (Past, courtesy Drew County Archives; present, courtesy Rebecca Spencer.)

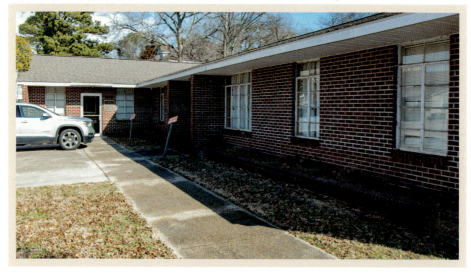

The city park has greatly expanded with the construction of public buildings, monuments, and playground equipment to accommodate the growing city since the municipal swimming pool was constructed in 1936. Monticello is one of only two cities in Arkansas to receive the coveted Playful City USA designation by the national nonprofit Kaboom! (Past, courtesy Mark and Rebecca Spencer; present, courtesy Rebecca Spencer.)

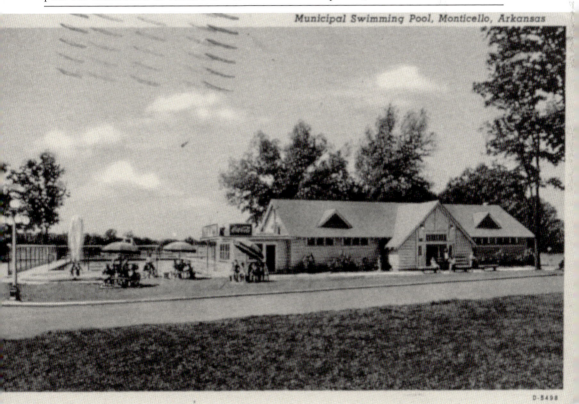

COMMUNITY

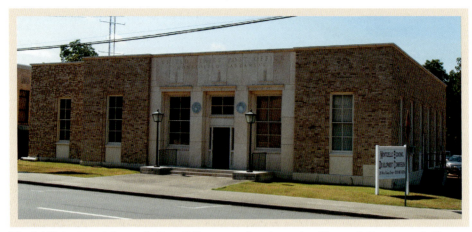

The "old" Art Deco Monticello Post Office was constructed in 1937. In 1941, in recognition of Monticello as the "Tomato Capital of Arkansas," a terra cotta sculpture by Berta Margoulies entitled "Tomato Sculpture" was installed in the building. The post office was listed in the National Register of Historic Places on August 14, 1998, and now houses the Economic Development Commission. (Past, courtesy UAM Library; present, courtesy Rebecca Spencer.)

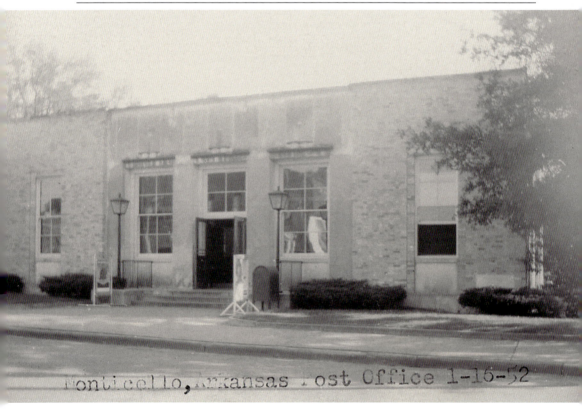

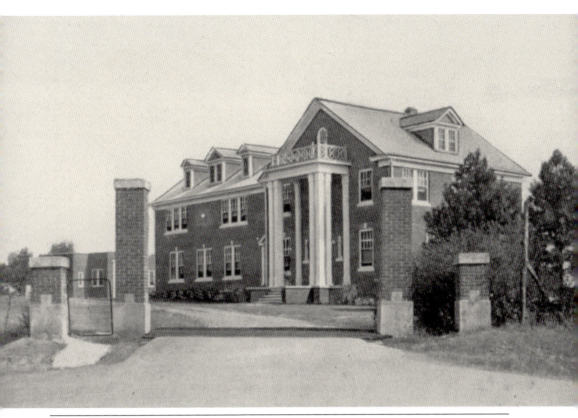

The Vera Lloyd Presbyterian Home for Children was established in 1910 as a nursery for children whose mothers worked at the Monticello Cotton Mill. The home initiated the expansion of its mission when twin girls were abandoned at the local train depot. Because there was no proof that the girls were true orphans, they were not eligible for state orphanages, so the nursery took them in. (Past, courtesy Drew County Archives; present, courtesy Rebecca Spencer.)

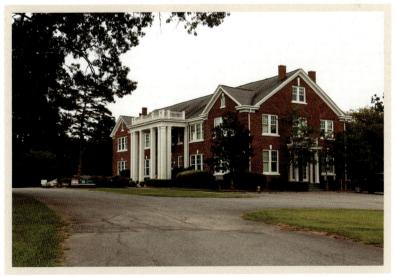

COMMUNITY

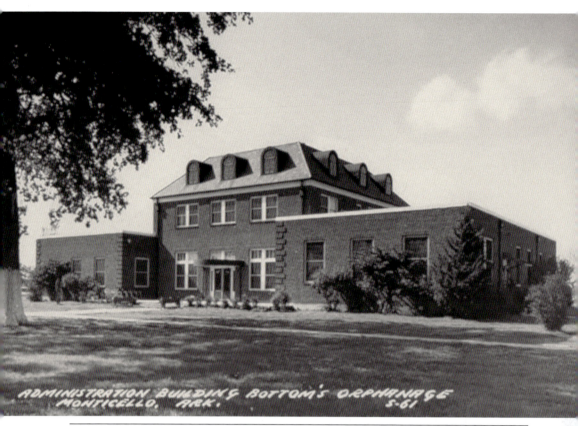

In 1887, Hannah Hyatt began caring for orphans in her home. In 1894, she donated her house and 80 acres to the state Baptist convention, thereby initiating the establishment of the Arkansas Baptist Home for Children. In response to generous donations from George Bottoms and his wife in 1923, the home was re-named Bottoms Baptist Orphanage. In 1961, the Baptist convention changed the name back to Arkansas Baptist Home. (Past, courtesy Drew County Archives; present, courtesy Rebecca Spencer.)

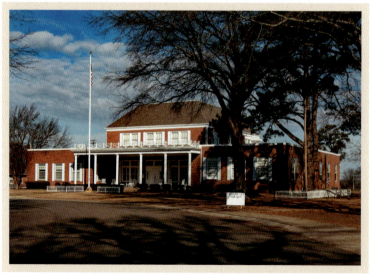

CHAPTER 5

HOMES
REFLECTIONS OF PURPOSE AND PERSONALITY

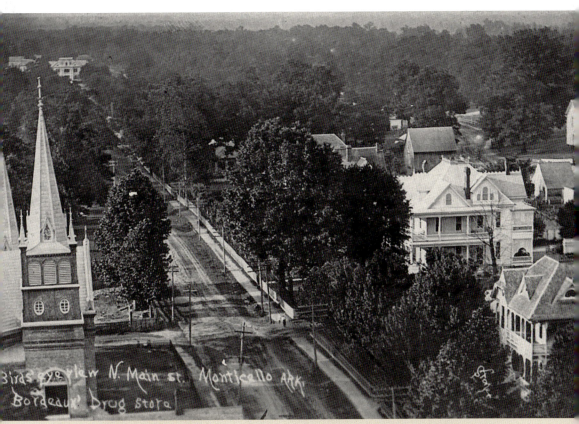

This 1920s postcard shows North Main Street from First Baptist Church running north to the Bertie Erwin House. A historic district in the National Register of Historic Places, North Main is still occupied by prominent homes such as the Trotter House, the McCloy House, the Arthur Wells House, and the Allen House. The Bertie Erwin House burned in 1928. (Courtesy Mike Pomeroy.)

Bertie Erwin stands at her front gate, the J.Y. Erwin home in about 1900. This grand house at the end of North Main Street was struck by lightning and burned in 1928. The site was donated to the city and became the location of the county hospital in about 1950. The new Monticello Branch Library constructed in 2014 now occupies the site. (Past, courtesy Drew County Archives; present, courtesy Rebecca Spencer.)

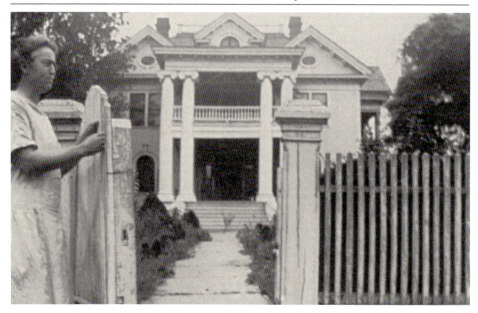

HOMES

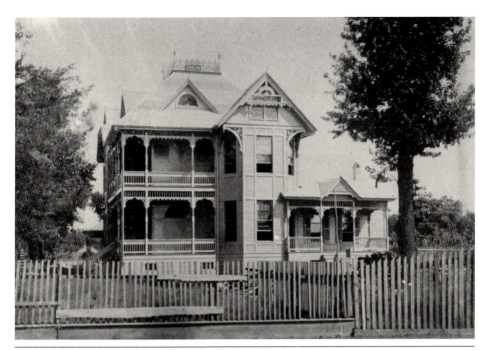

The Trotter House was built in 1896 by one of Monticello's most prominent businessmen, V.J. Trotter Sr. In the 1910 census, the Trotter House was valued at $15,000, more than any other house in Monticello at that time. The Trotter House is now a bed-and-breakfast owned and operated by the University of Arkansas at Monticello. Each of the six guest rooms is named after a tree indigenous to southeast Arkansas. (Past, courtesy UAM Library; present, courtesy Rebecca Spencer.)

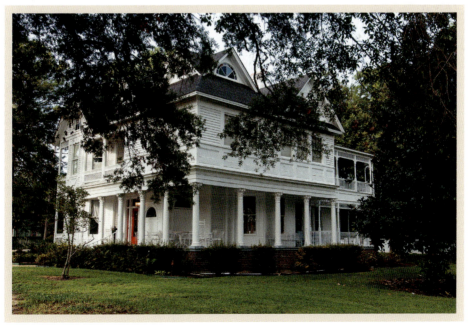

HOMES

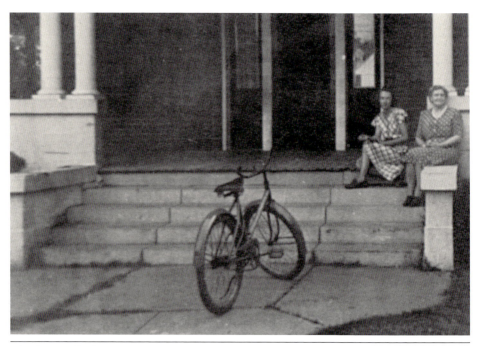

The historical photograph of this home on North Main Street was taken in 1946. Seated on the front steps are Bernice Wilson Holder and her mother-in-law. Bernice Holder was married to Dr. James Bartley Holder Jr., who was one of the owners of the Mack Wilson Hospital in the 1940s. The hospital was next door. Remodeled in the 1950s, the house is now owned by Corey and JJ Sellers. (Past, courtesy Drew County Archives; present, courtesy Rebecca Spencer.)

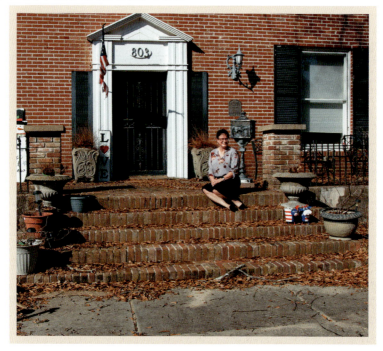

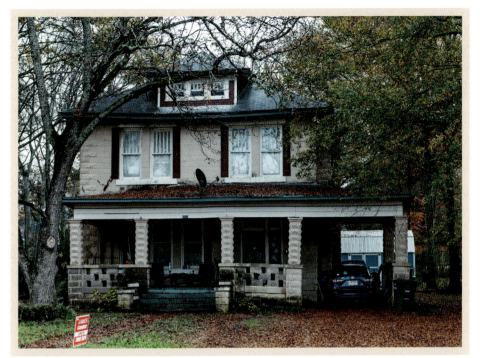

In 1906, Arthur Lee Wells began construction on the Sears catalog house pictured here on North Main Street. His wife, Genevieve, was the half-sister of the prominent Texaco oil executive Prentiss Hemingway Savage, the love interest of Ladell Allen in 1948. Genevieve, a long-time friend of Ladell's, was one of Ladell's confidants in regard to the relationship. (Past, courtesy Betty Evans; present, courtesy Rebecca Spencer.)

Homes 75

In 1906, Arthur Wells purchased a block-making machine from Sears for $39.95. In addition to his house on North Main, the block-making machine was used for the Mittie Brooks house, pictured here, at the corner of North Main Street and Oakland. The same block-making machine was used for the construction of the Christian Science Church on North Main and the Cavaness House (now the Drew County Museum). (Past, courtesy Drew County Archives; present, courtesy Rebecca Spencer.)

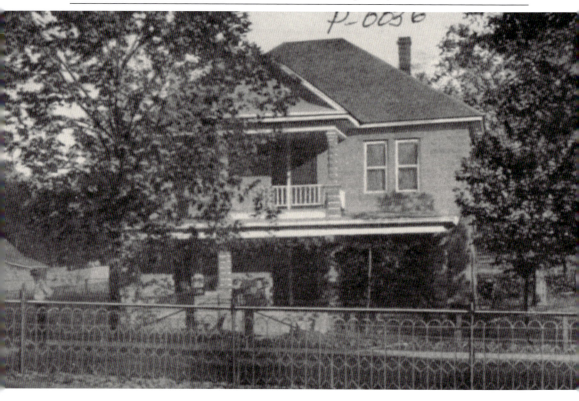

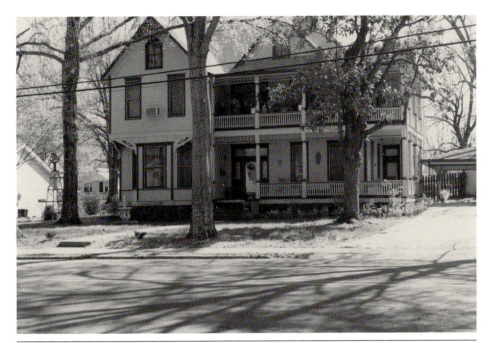

The McCloy house on North Main Street was the home of businessman John J. McCloy, the co-owner of Monticello's most enduring mercantile store. McCloy and Virgil J. Trotter Sr. formed McCloy & Trotter Mercantile and Grocery on the Square in 1881. After McCloy's death, the business became V.J. Trotter & Sons and remained such until it was sold in 1970. (Past, courtesy Drew County Archives; present, courtesy Rebecca Spencer.)

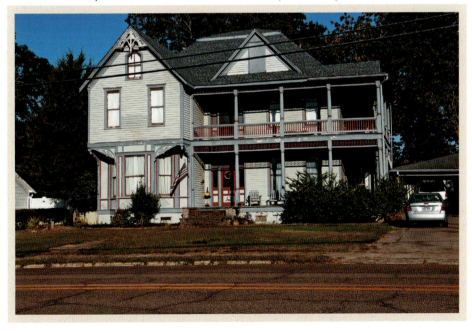

HOMES

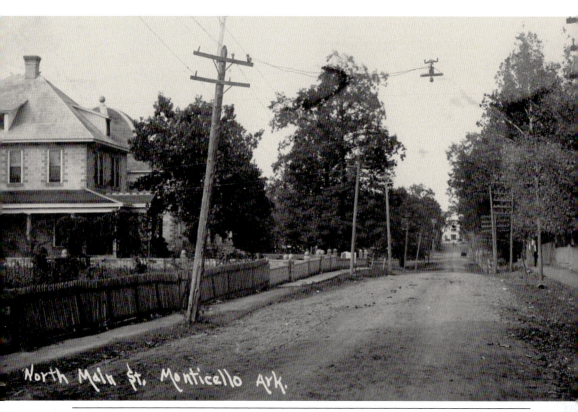

The c. 1920 photograph of North Main provides a glimpse of the Bertie Erwin house at the end of the street, now the location of the recently constructed public library. The concrete block (Sears catalog) house on the left served as the offices of Dr. Robert Hyatt and Dr. Lewis Hyatt for many years. It was razed to expand parking for the First Baptist Church. The recent photograph provides a good view of the Christian Science Church built in 1909. (Past, courtesy Drew County Archives; present, courtesy Rebecca Spencer.)

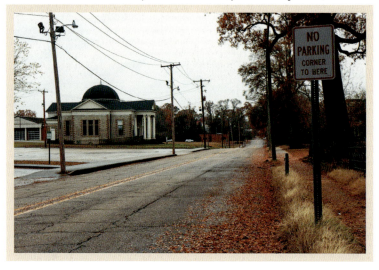

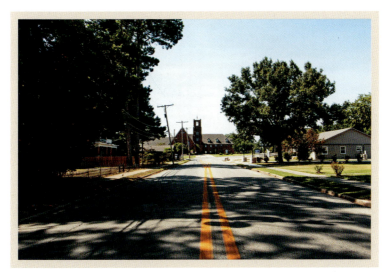

Taken in the mid-1920s, the historical photograph of South Main Street shows homes on the left side that still stand today, including the Pope House designed by Chicago-trained architect Sylvester Hotchkiss in 1905. Dr. Mardell Yates Pope (1869–1948) practiced medicine in Monticello from 1894 until 1944. At the end of this stretch of South Main Street is the Methodist church built in 1911. (Past, courtesy Mark and Rebecca Spencer; present, courtesy Rebecca Spencer.)

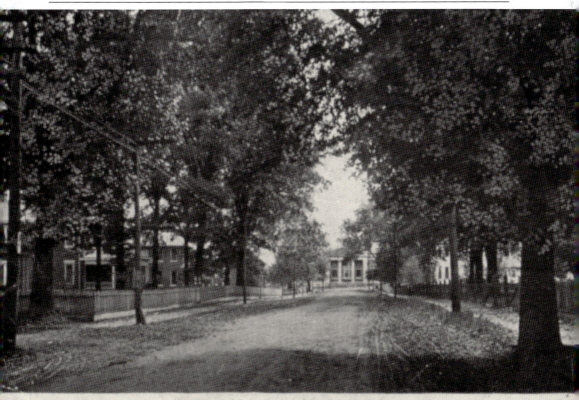

HOMES 79

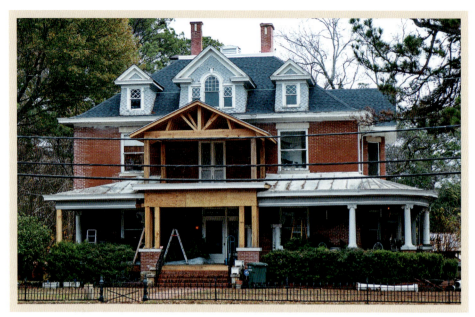

Built in 1908 at 207 South Main Street during Monticello's Golden Age of immense commercial prosperity, the Hardy House was the home of Robert Lee Hardy, a prominent local attorney. The home was designed by the Tennessee-based architect George Franklin Barber and has been in the National Register of Historic Places since 1982. (Past, courtesy Drew County Archives; present, courtesy Rebecca Spencer.)

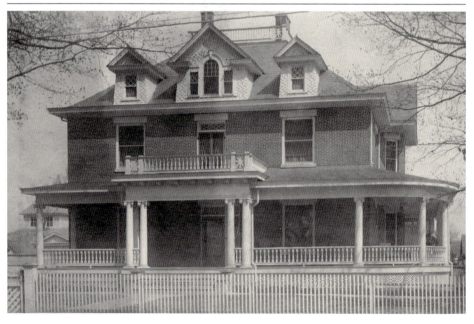

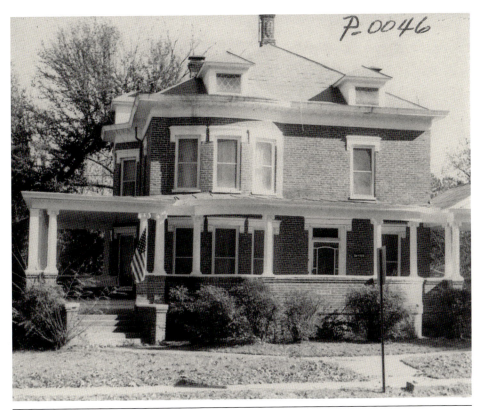

On South Main Street, the home of Dr. Mardell Yates Pope (1869–1948) was built about 1902, another Sylvester Hotchkiss design. Pope was the son of Dr. Jenkins Devaney Pope (1825–1910) and Sarah Reeves Pope. The family moved to Monticello in 1881. M.Y. Pope graduated from the Medical College of Philadelphia, Pennsylvania, and practiced in Monticello until he retired in 1944. (Past, courtesy Drew County Archives; present, courtesy Rebecca Spencer.)

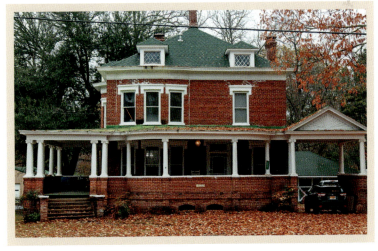

HOMES

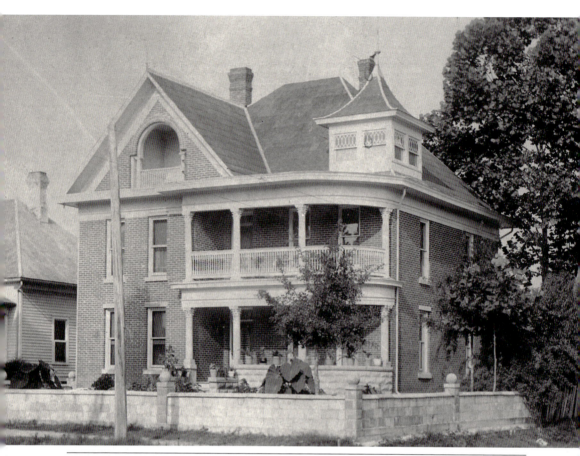

The home of Dr. Albert Sidney Johnston Collins stood on South Main Street where the Farmers' Market is now held. Dr. Collins graduated from Memphis Hospital College in 1896 and practiced in Lincoln County prior to moving to Monticello in 1902. He practiced in Monticello until his death in July 1945. His doctor's bag is part of the collection at the Drew County Historical Museum. (Past, courtesy Drew County Archives; present, courtesy Rebecca Spencer.)

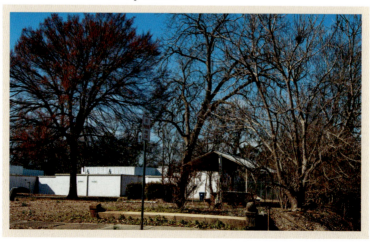

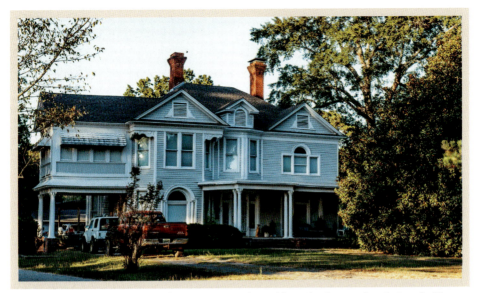

Located on Bolling Street, the Calvin T. Harris house was built in 1904. Preserved very nicely is the design of Sylvester Hotchkiss (1842–1909), who was born in New York and studied carpentry and architecture in Chicago. Because he was also a carpenter, he built the staircases himself in the houses he designed. He was particularly fond of Eastlake design, part of the Queen Anne style of Victorian architecture. (Past, courtesy Drew County Archives; present, courtesy Rebecca Spencer.)

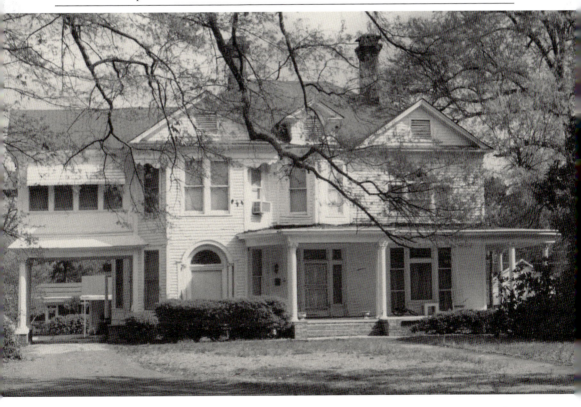

This was the home of the architect Sylvester Hotchkiss. Built around 1895, the house was a showcase for Hotchkiss's designs. Each room has distinct moldings and windows. Hotchkiss proclaimed in his advertising, "I make plans specially adapted and intended for the needs of those residing in the South, where summers are long and hot—we want none of the cubbyhole rooms and low-ceilings so common in the North." (Past, courtesy Drew County Archives; present, courtesy Rebecca Spencer.)

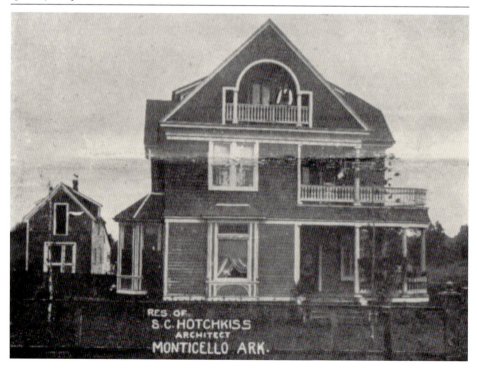

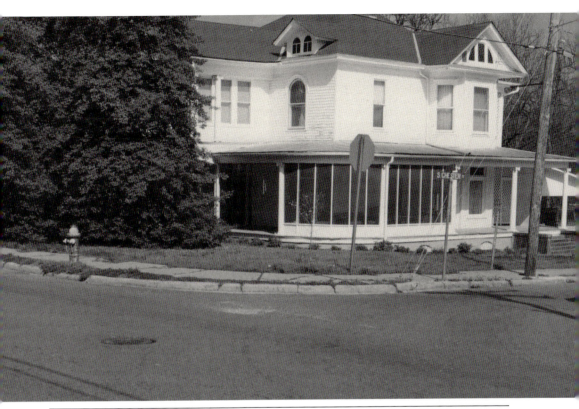

The Lambert house has been listed in the National Register of Historic Places since 1983. Built in 1905 at 204 West Jackson Street, the Lambert house is a Colonial Revival designed by the noted architect Sylvester Hotchkiss. A prominent feature is its two-story portico, the second story of which has been enclosed as a sunroom. The interior features Hotchkiss's air-flow design meant to assure relative comfort during hot summers. (Past, courtesy Drew County Archives; present, courtesy Rebecca Spencer.)

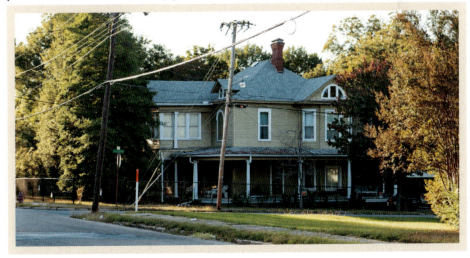

Homes

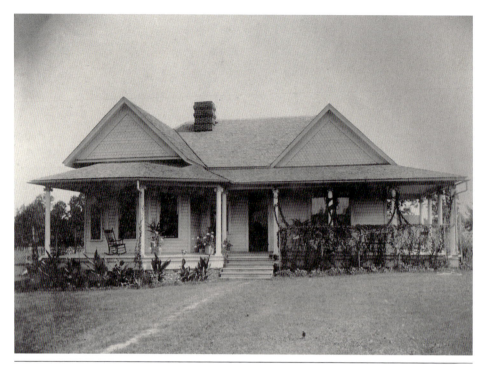

Located on Wood Avenue, the W.H. and Eugenia McQuiston home was built in 1915. Will McQuiston operated a drugstore in the Masonic building on the west side of the square starting around 1890, along with Dr. W.A. Brown, who practiced medicine in Monticello from 1889 until his death in 1916. (Past, courtesy Drew County Archives; present, courtesy Rebecca Spencer.)

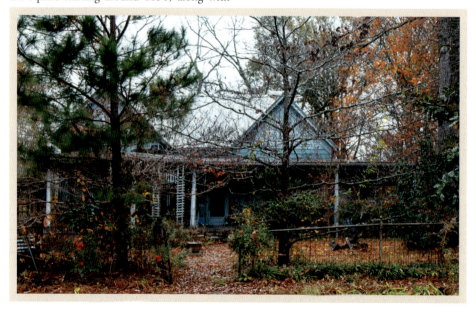

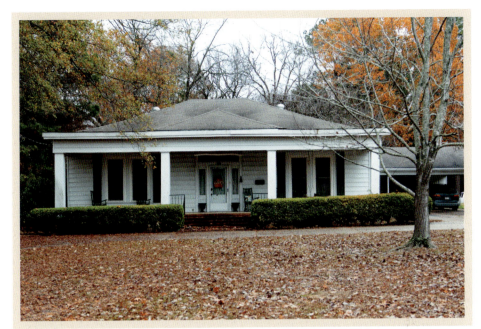

Known as the Moffatt home, W.T. Wells bought this house in 1905 and lived there with his daughters Minnie and Myrtle. Myrtle married W.A. Moffatt, and until their deaths, they lived in the house with their daughters Minnie Mae and Pattie and son Walter, who was a graduate of Harvard University and a longtime faculty member of Arkansas A&M College. (Past, courtesy Drew County Archives; present, courtesy Rebecca Spencer.)

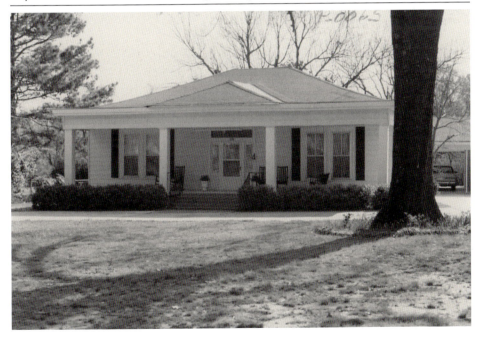

Homes

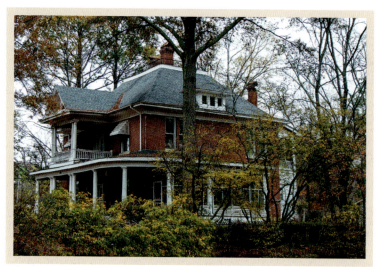

Lynn Shrum, the current owner, believes that her house was built prior to 1910 as a frame construction and was moved to its current location on North Main Street and then was bricked. It is situated across from the lot that held the old Monticello Hospital and is now occupied by the public library. The house features an interior elevator dating to as early as 1910. (Past, courtesy Drew County Archives; present, courtesy Rebecca Spencer.)

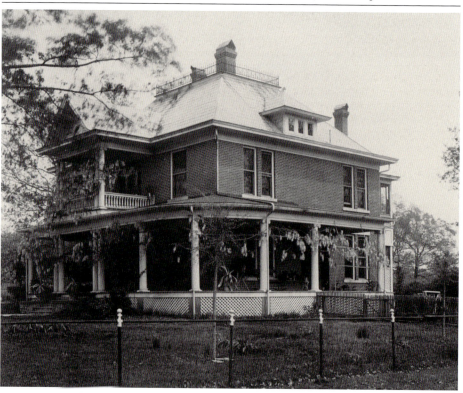

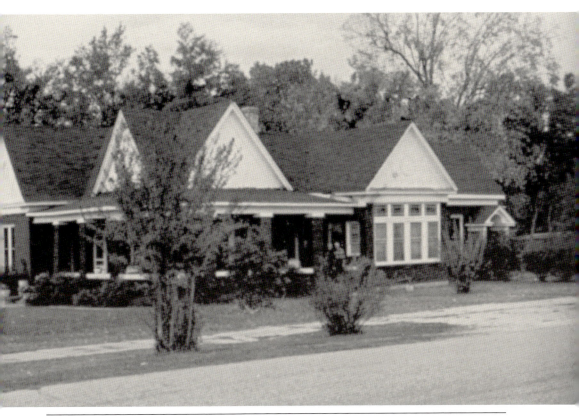

On Wood Avenue, the home of Mac Wilson was built circa 1900. Wilson's donations made the construction of Monticello's first hospital possible in 1930. The Mac Wilson Hospital was located on North Main Street and remains to this day as part of the First Presbyterian Church. Dr. John Samuel Wilson was the director of the hospital and purchased it in 1937, operating it until his death in 1946. (Past, courtesy Drew County Archives; present, courtesy Rebecca Spencer.)

HOMES

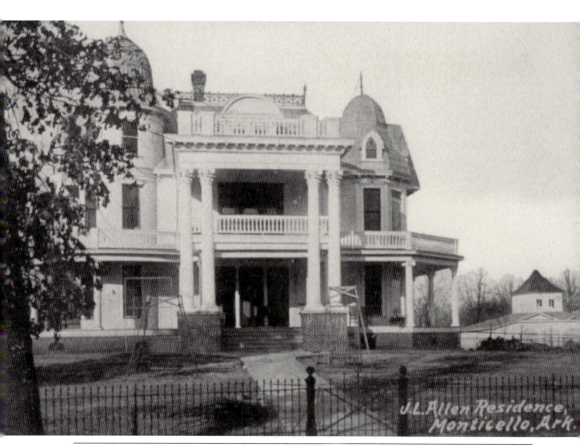

Constructed in 1906 by entrepreneur Joe Lee Allen as a monument to his success, the Allen House was featured on several postcards of the early twentieth century because of its striking architecture. The house is now famous for its reputed paranormal activity and has been featured on several television shows, is the subject of a bestselling book, and was the location of a feature-length movie in 2016. (Past, courtesy Mark and Rebecca Spencer; present, courtesy Rebecca Spencer.)

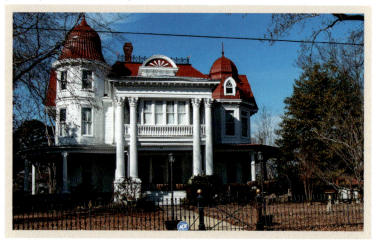

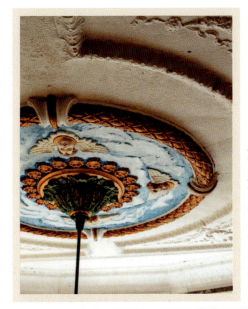

The highly ornate dining room ceiling at the Allen House was constructed on site in 1905. The hand-beaten tin ceiling was a unique element for house designs by the architect Sylvester Hotchkiss. Joshua Barkley White was the builder of the house. The ceiling is fully intact today with some meticulous painting accenting its details. (Past, courtesy Mark and Rebecca Spencer; present, courtesy Rebecca Spencer.)

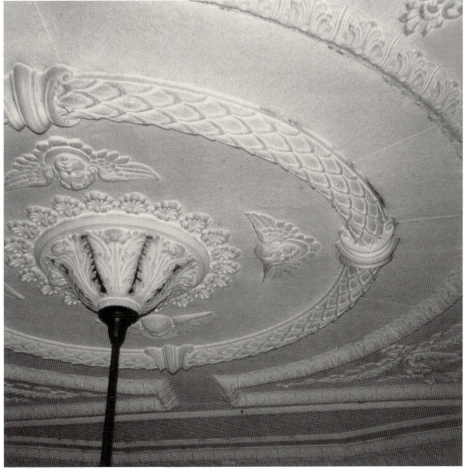

From 1955 until 1985, the Allen House was divided into apartments furnished with original Allen family pieces, and the dining room served as a bedroom. Above the head of the tenant in the historical photograph, the bottom of the chandelier is visible with its original fringe. The fringe, which is still on display at the house, has been replaced by crystals. (Past, courtesy Mark and Rebecca Spencer; present, courtesy Rebecca Spencer.)

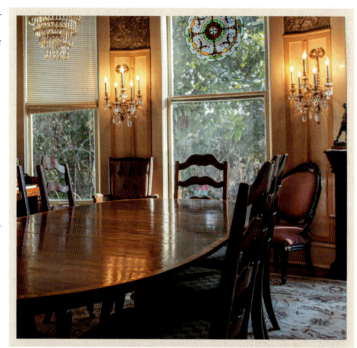

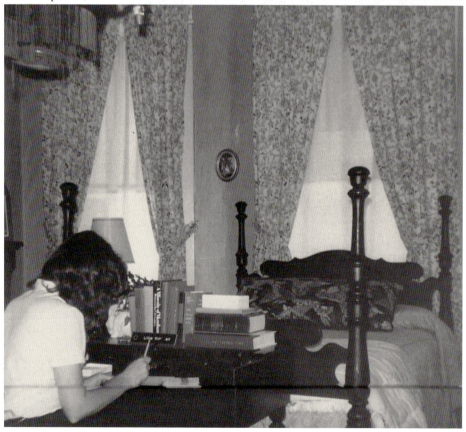

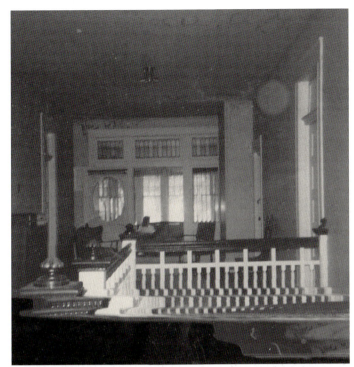

In early 1949, Caddye Allen sealed the master bedroom suite of her home with padlocks as a memorial to her daughter Ladell. The tenant seen here had the house to herself in the 1970s because of the widespread belief that the house was haunted. Seen in the 2023 photograph are Ellawyn and Chaplin Spencer on the couch. Standing in the enclosed sleeping porch is Gatsby Spencer. (Past, courtesy Mark and Rebecca Spencer; present, courtesy Rebecca Spencer.)

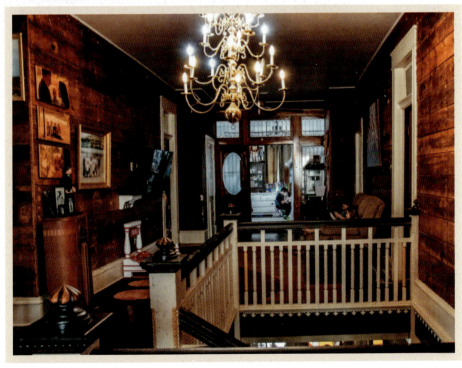

HOMES

93

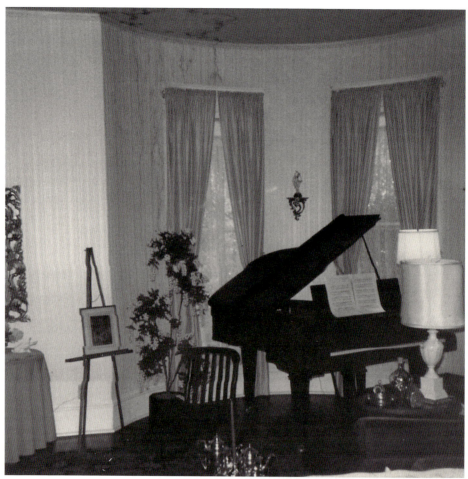

This is the south end of the Allen House music room. The Allen daughters, Ladell (1894–1949), Lonnie (1892–1955), and Lewie (1897–1944), frequently entertained guests by playing the baby grand piano seen here. Their parents, Joe Lee (1863–1917) and Caddye Allen (1871–1954) were quite fond of giving parties in their home, as well as at their hotel. Today, the room is used primarily as a library. (Past, courtesy Mark and Rebecca Spencer; present, courtesy Rebecca Spencer.)

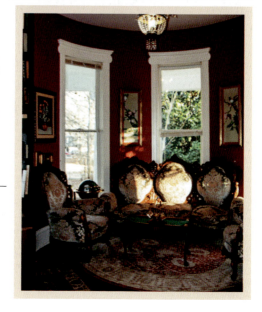

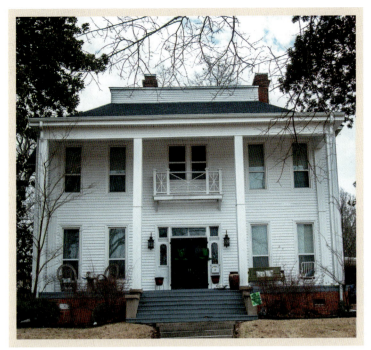

Built around 1903, this majestic residence on North Main Street has been home to six generations of the Hyatt family: David Taylor and Diantha Lewis Hyatt; Robert Fee Hyatt Sr.; Dr. C. Lewis Hyatt Sr. and Wanda Hyatt; and C. Lewis Hyatt Jr. and Charlotte Hyatt McGarr, whose daughter Carole Martin has lived in the house with her sons John Michael and Max Hyatt Efird since 2009. (Past, courtesy Carole Martin; present, courtesy Rebecca Spencer.)

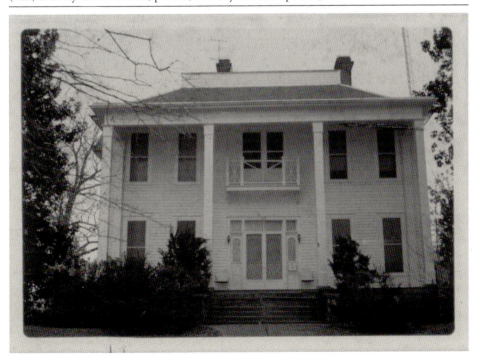

HOMES

Discover Thousands of Local History Books Featuring Millions of Vintage Images

Arcadia Publishing, the leading local history publisher in the United States, is committed to making history accessible and meaningful through publishing books that celebrate and preserve the heritage of America's people and places.

Find more books like this at
www.arcadiapublishing.com

Search for your hometown history, your old stomping grounds, and even your favorite sports team.

Consistent with our mission to preserve history on a local level, this book was printed in South Carolina on American-made paper and manufactured entirely in the United States. Products carrying the accredited Forest Stewardship Council (FSC) label are printed on 100 percent FSC-certified paper.